FREUD

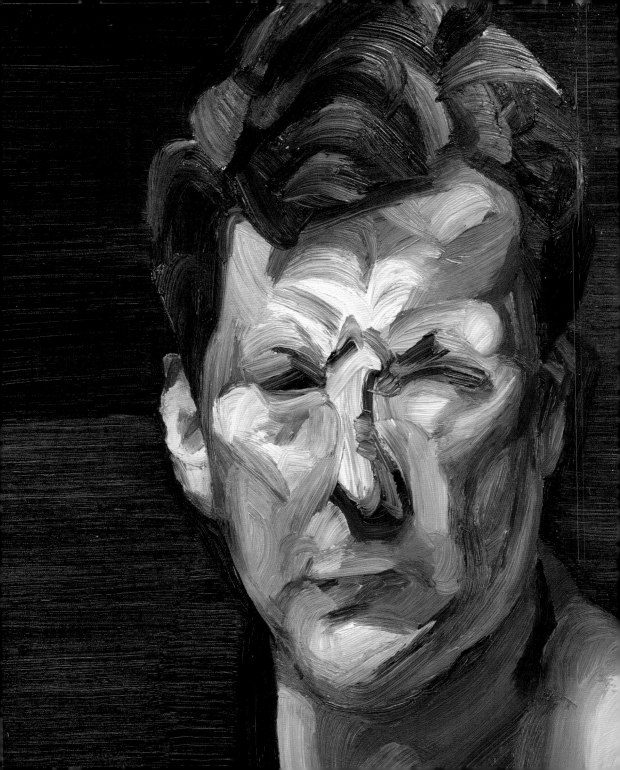

MASTERS OF ART

FREUD

Brad Finger

PRESTEL
Munich · London · New York

Front Cover: Reflection (Self-Portrait), 1985

© Prestel Verlag, Munich · London · New York 2020
A member of Verlagsgruppe Random House GmbH
Neumarkter Strasse 28 · 81673 Munich

Prestel Publishing Ltd. Prestel Publishing
14–17 Wells Street 900 Broadway, Suite 603
London W1T 3PD New York, NY 10003

A CIP catalogue record for this book is available
from the British Library.

Editorial direction Prestel: Constanze Holler
Picture editing: Stella Christiansen
Copyediting: Vanessa Magson-Mann, So to Speak, Icking
Production management: Andrea Cobré
Design: Florian Frohnholzer, Sofarobotnik
Typesetting: ew print & medien service gmbh
Separations: ReproLine Mediateam
Printing and binding: Litotipografia Alcione, Lavis
Typeface: Cera Pro
Paper: 150g Profisilk

MIX
Paper from
responsible sources
FSC® C021956

Verlagsgruppe Random House FSC® N001967

Printed in Italy

ISBN 978-3-7913-8627-0

www.prestel.com

CONTENTS

INTRODUCTION

"Painters who use life itself as their subject-matter, working with the object in front of them or constantly in mind, do so in order to translate life into art almost literally, as it were. The subject must be kept under closest observation: if this is done, day and night, the subject—he, she, or it—will eventually reveal the *all,* without which selection itself is not possible; they will reveal it, through some and every facet of their lives or lack of life, through movements and attitudes, through every variation from one moment to another. It is this very knowledge of life which can give art complete independence from life, an independence that is necessary because the picture, in order to move us, must never merely *remind* us of life, but must acquire a life of its own, precisely in order to *reflect* life. I say that one needs a complete knowledge of life in order to make the picture independent from life, because, when a painter has a distant adoration of nature, an awe of it, which stops him from examining it, he can only copy nature superficially, because he does not dare to change it." (from Lucian Freud's essay, *Some Thoughts on Painting*, 1954)

Lucian Freud was still in his early thirties when he penned these words for the newly founded *Encounter* magazine. They were part of a larger article in which he described his philosophical approach toward painting. For most artists of his age, such an essay might have been dismissed as pretentiousness. But Freud was no ordinary thirty-something. He had become a celebrity in both the art world and the larger cultural scene of post-war Britain. Born into fame as the grandson of Sigmund Freud, the founder of psychoanalysis, Lucian had made a daring escape from Nazi Germany in the early 1930s. He then channelled his aptitude for portraiture, noticed from his earliest days in art school, into a rapidly growing career. Freud was also endowed with an intense personal magnetism, which combined striking good looks, nervous energy and a gift for mingling with both the social elite as well as the bohemian underground. Lucian's two marriages, one to the daughter of an artist and the other to an heiress, were both short-lived, as the painter's restive spirit led him into numerous affairs.

Lucian's restless nature belied somewhat his way of making art. Freud became infamous for his excruciatingly deliberate technique, which often required his subjects to sit for hours on end—"day and night"—over several weeks or months. Freud would focus obsessively on the physical details of each sitter, details he believed would help define that sitter's personality in paint. Freud seemed to derive his great-

est pleasure from the art-making process, rather than the finished product. In his article for *Encounter*, he wrote that "the process of creation becomes necessary to the painter perhaps more than is the picture. The process in fact is habit-forming."

Because of Freud's meticulous working method, his style evolved slowly. As a young man, he was influenced by the Expressionist works of his then current teacher, Cedric Morris. Lucian's early portraits and still lifes featured the flattened shapes, earthy colours and oversized eyes that also characterise Morris' work. But by the 1950's, Freud's faces were becoming fleshier and more rounded. This change in style was due, in part, to changes in his technique. Freud abandoned the delicate sable brushes of his youth and began using hogs-hair brushes, which enabled him to apply paint more thickly and expressively. He began to highlight imperfections in the skin, as well as the more subtle effects of light and shade on the skin's surface. Later on, Freud would expand his notion of the portrait to include the entire body. He would state that the face was merely a "limb", and therefore could not give a complete impression of a sitter's character. For these "body portraits", Freud's models would often pose in a splayed or physically contorted position on beds, sofas or piles of rags, imbuing his compositions with an emotional charge. Lucian seemed especially drawn to sitters of unusual proportion, such as the corpulent performance artist Leigh Bowery or the rake-thin fashion model Kate Moss.

Freud's story also involves his turbulent relationship with Francis Bacon. Both men, in their own way, rejected Abstract art and other characteristically modernist styles. Instead, they worked tirelessly with the figural image and the portrait—re-interpreting these traditional motifs to create a specifically British art. For a time, especially in the 1950s, Freud was inspired by Bacon's dramatically warped faces and bodies, as well as his use of imagery from Velázquez and other Old Masters. The two men's friendship would ultimately sour, but Freud's later work would show some of Bacon's influence, from its psychological intensity to its creative use of massing and shade.

Freud continued to make art until his death in 2011. As he aged, his art increasingly revealed a desire for more intimacy with his subjects—subjects that included artists, aristocrats, writers, performers and even British royalty. Freud seemed to use these images to expose something of his own character. They, along with Lucian's self-portraits, provide us with a kind of autobiography in paint.

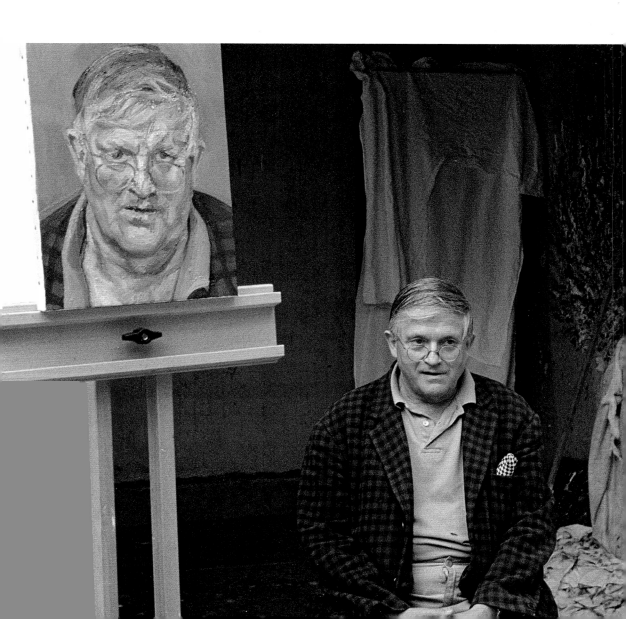

LIFE

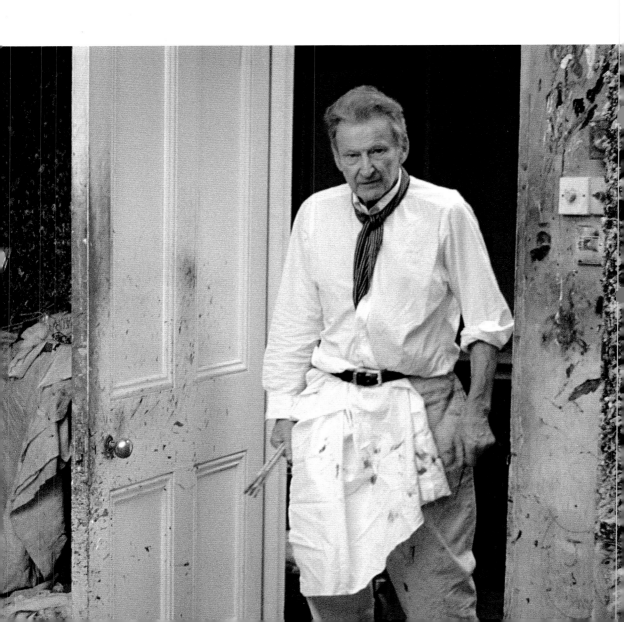

INHERITOR OF A FAMILY LEGACY: 1922–1939

"I did a bit of sculpture at school, a small alabaster fish lying on a rock and I thought it was rather good and gave it to him and he seemed to like it. He had a collection of antique sculpture. Marie Bonaparte was with him and he gave her the fish saying, 'I'm sure you won't mind my giving it to Princess Marie because when you become an artist, she will be your first patron.'

He seemed fairly youthful, even in London; he had such humour and wisdom, very light-hearted really.

… The thing is my grandfather was a very cultivated man; he seemed marvellously understanding and amused. I think the more deeply cultivated you are, the stronger position you are in to deal and understand the things which, on the face of it, might well be abhorrent to you, and things which might engender fear and disgust and even hate." (Lucian Freud on his grandfather, Sigmund Freud, from an interview with art critic and author William Feaver, 1992)

Lucian Freud was born in the early 1920s, at a time when his grandfather, Sigmund Freud, had achieved worldwide fame. The Viennese neurologist had helped popularise the study of mental illness and the unconscious mind. His theories on how childhood sexual abuse and other repressed memories could lead to mental disorder (or "hysteria"), along with his use of a "talking therapy" to uncover these memories, led to a world wide medical phenomenon called psychoanalysis. Freud's ideas not only revolutionised the medical community, they also had a profound impact on Western culture. Painters, writers, filmmakers and other artists began to explore the role of the subconscious in their work. Such efforts were especially prominent among Surrealist artists, such as Salvador Dali, André Breton, Paul Éluard and André Masson. Surrealists popularised the technique of automatism or the use of random or chance elements to construct artwork that lacked pre-planning or conscious direction.

Sigmund Freud's fourth child, Ernst, was born in 1892 and showed an early interest in art. By 1920, after serving briefly in World War I and completing his studies at Munich's Technische Universität (Technical University), he had settled in Berlin, begun an architectural practice and married Lucie Brasch, the daughter of a wealthy Berlin corn merchant. Unusually for the time, Ernst decided to incorporate part of his wife's name—the 'L' in Lucie—as his middle initial. Lucie's name would also be the inspiration for his second son, Lucian, who was born on December 8th, 1922.

Young Lucian was living at the heart of Germany's Weimar Republic, at a time when Berlin was undergoing a cultural revolution. Germany had recently lost the Great War and was weighed down by heavy reparation payments to France, Great Britain and the other Allied Powers. The war had also transformed the psyche of Berlin's people. Soldiers returning from the battlefields had experienced, for the first time, the horrors of

Sigmund Freud with two of his grandsons, Anton Walter (left) and Lucian Freud (right), 1938

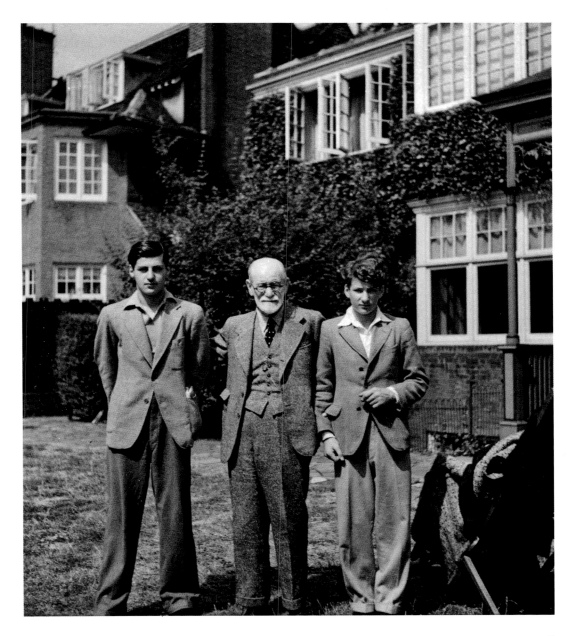

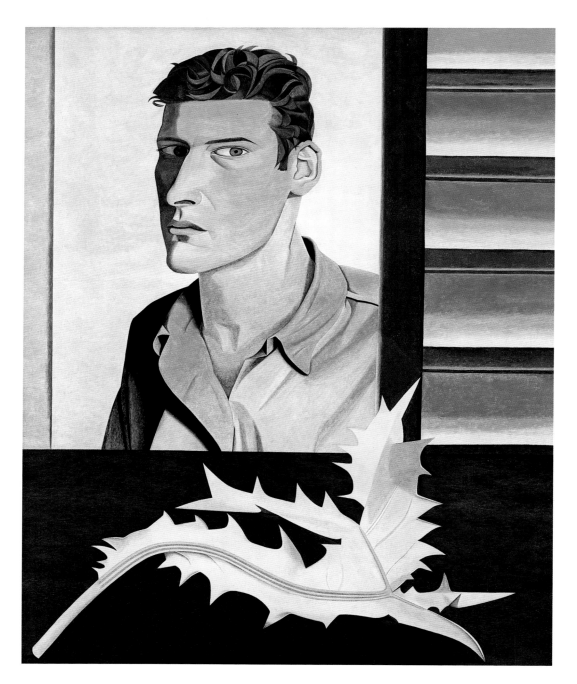

mechanised warfare—horrors that now seemed pointless to both the defeated nations. Public cynicism grew out of this environment, leading to changes in German society and cultural life. In Berlin, conservative traditions and values were confronted by avant-garde Expressionist and Surrealist art, as well as a cabaret culture that flaunted sexual non-conformity and upended social mores. Some of these changes had begun before the war, but they were now becoming more openly visible to the everyday people of Berlin. Even Ernst Freud's architectural practice reflected these changes, as he developed a modernist style similar to that of the Bauhaus school.

However, Lucian and his two brothers, Stephen and Clement, saw relatively little of these radical changes. Their parents were able to provide them with a comfortable bourgeois lifestyle. The Freud's home, an expansive flat in the wealthy Tiergarten district of Berlin, near the Berlin zoo and Tiergarten park, was complete with nannies, maids and a cook. From an early age, Lucian was exposed to fine art. His family owned prints by leading old masters, including Hokusai, Albrecht Dürer, and Pieter Bruegel the Elder. Ernst also supervised the home's interior decoration, combining his own furniture designs with a modernist De Stijl cupboard and other refined decoration. This wealth of culture at home was supplemented by trips to Berlin's museums and institutions. Lucian was especially fond of the Egyptian Museum, with its famous bust of Nefertiti, and he would later use Egyptian busts as inspiration for his portraiture. Freud's proximity to the zoo helped spur another lifelong interest—that of animals and the natural world.

Despite the trappings of middle-class comfort, Freud's family was soon forced to deal with the rising tide of anti-Semitism and Nazism in Germany. As he stated himself in an interview with newspaper editor Geordie Grieg, "Politics loomed over everything, even when I was nine. I was at an ordinary school in Berlin and some boys would say, 'Oh, we are going to the Nazi rally,' and I would say, 'Can I come?' and they would say, 'No, you can't, but you're not really missing anything. We sing songs.' They made it sound innocent." Lucian also remembered seeing and photographing Adolf Hitler in 1931, describing him as a man with "huge bodyguards" who "was really very small". By this time, the young Freud had become "aware of being a Jew".

Like many well-to-do Jewish families in Weimar Berlin, the Freuds did not practice Judaism in the synagogue. They did, however, maintain a strong Jewish cultural identity. Since his student days, Ernst Freud had been involved in the Zionist movement to establish a Jewish homeland in what is now Israel; and some of his more important Berlin clients were active Zionists. The Freuds' prominence in the Jewish community put their safety at great risk when Hitler came to power in early 1933. In April of that year, Lucian's uncle Rudolf Mosse was killed in an anti-Semitic attack by Nazi henchmen. This event may have been the tipping point for Ernst and Lucie Freud, as they soon decided to leave the country and move to England. Lucie and the three boys would emigrate

in September, and by the end of the year the entire family was living in a flat on Clarges Street in London's Westminster quarter.

It is likely that these dramatic events had a significant emotional effect on the eleven-year-old Lucian. He had always been a rebellious child, but he now began demonstrating violent behaviour. At his first school, a progressive institution called Dartington Hall in rural Devon, south of London, Lucian was known to throw rocks at horses and fight with other boys. After being expelled from Dartington, he showed similar disruptive behaviour at his next two schools, Braynston in Dorset and the Central Arts and Crafts School in London. Freud studied only a brief time at both places, but he began showing his talent for art. Lucian's sculpture of an alabaster fish, likely done at Central Arts and Crafts in 1938, was admired by his grandfather Sigmund, who had recently escaped from Vienna and settled in London. Princess Marie Bonaparte, the grandniece of Napoleon, had helped Freud escape, and Lucian remembered his grandfather asking him to make Marie his "first patron" by giving her the fish as a gift. Though they spent only a limited time together, Lucian and Sigmund Freud had a rather happy relationship. Sigmund always admired Lucian's interest in art, and he supplied him with encouragement as well as prints and illustrations from which to study. Photographs and a short film taken in 1938 show Lucian and his grandfather together in the garden of Sigmund's London home, which is now a museum dedicated to Freud's life and career.

Lucian's relationship with other family members was less sanguine. His father was somewhat remote and hard to please, rarely exhibiting praise for his son's artistic talent. His mother, on the other hand, practically suffocated her favourite son with attention. Freud would later describe her as treating him like "an only child" and that he "resented her interest". This closeness between Lucie and Lucian may have also led to strained relationships with Stephen and Clement. Records from their school days indicate a certain resentment among the three. Ultimately, Lucian would have a falling out with both brothers over money matters, and he would become permanently estranged from Clement.

Lucian's tumultuous life would reach an important crossroads in 1939. His beloved grandfather, who had long suffered from cancer of the jaw that limited his speech, died on September 23rd. Lucian did not attend the funeral, but he remembered Sigmund's corpse having a "sort of hole in his cheek like a brown apple". This event coincided with the beginning of World War II in Britain, as well as Lucian's enrolment in the East Anglia School of Painting and Drawing. The young Freud would now begin his art career in earnest, making his own mark in the Freud family's rich cultural tradition.

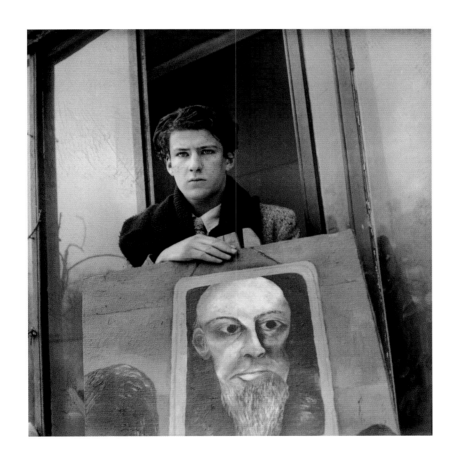

Francis Goodman, *Lucian Freud*, 1945

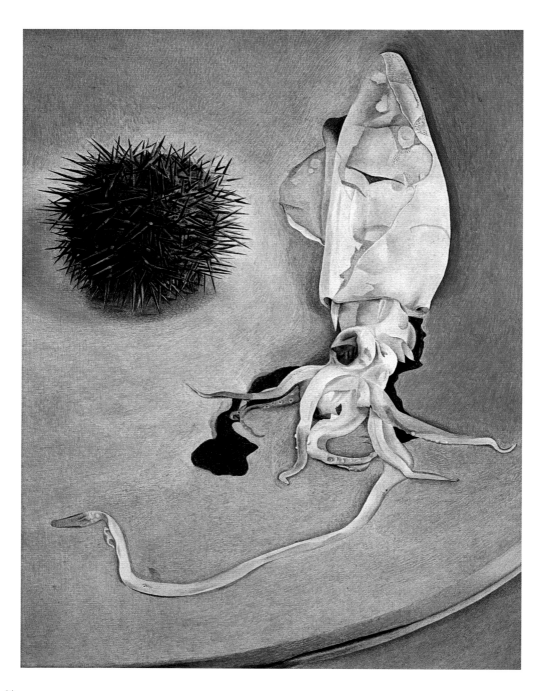

Still life with Squid and Sea Urchin, 1949

THE STUDENT ARTIST: 1939 – 1947

"He worked in a very odd way. Used to start at the top as if he was unrolling something that was actually *there*. Even when he was painting a portrait, he'd do the background and the eyes and then do the thing in one go and not touch it again. I thought Cedric was a real painter. Dense and extraordinary. Terrific limitations."
(Lucian Freud on painter and art teacher Cedric Morris, from an interview with William Feaver)

Lucian Freud first learned about the East Anglia School from a chance tip at the *Coffee An*, an all-night hangout in London's then-Bohemian Soho district. He had grown tired of the more formal Central Arts and Crafts School and was looking for a place where "there were models and you could work in your own room". Founded in 1937 by Cedric Morris and Arthur Lett-Haines at the village of Dedham in Essex, the school had adopted a hands-off approach toward its students. Direct teaching was kept to a minimum, and pupils were allowed to explore their creativity at their own pace. In this way, the East Anglia School resembled contemporary *écoles d'art* in Paris. The restless Freud would find his first artistic home there, and he would come to admire Cedric Morris's "dense", earthy, expressionistic portraits and flower paintings, as well as his method of working from top to bottom on the canvas.

Freud's time at East Anglia began with drama. A fire in July of 1939, shortly after Lucian had started there, destroyed the school's buildings. Freud and a colleague named David Carr were blamed by some for the blaze, as they had been smoking in the school. But no one was charged with the offense, and Morris and Lett-Haines eventually moved the institution in 1940 to a large Tudor house in Hadleigh, Suffolk called Benton End. Lucian Freud would spend periods of time at the school over the next several years, developing his nascent painting style.

Cedric Morris' influence on Freud's work from this period is evident. His portraits have the same flattened, expressionist intensity. They also reveal Lucian's life-long interest in ancient Egyptian art. The young painter had recently received a book of Egyptian portrait sculptures called *Geschichte Aegyptens* (1936), a gift from his early patron and friend Peter Watson, a wealthy art collector who helped support many young artists and writers. Lucian was struck with these ancient images, with their direct gaze and wide, almond-shaped eyes, and he would incorporate them into his own work, especially at this early stage. One of Freud's earliest paintings was, unsurprisingly, a portrait of Cedric Morris himself. Morris returned the favour and painted an image of Lucian in 1941, a sign of his regard for the talented up-and-comer.

Freud's life at this time was often chaotic. Using money he had won at a textile design competition, he made his way to Liverpool in early 1941 and joined the British Merchant Navy. For the next few months, he served on the SS Baltrover as an ordinary seaman, travelling to Halifax, Nova Scotia. Such journeys were treacherous in the

middle of wartime, as Liverpool was suffering under the Blitz—regular air bombings from the German Luftwaffe that had begun in August 1940. The Baltrover itself survived air and submarine attacks, making the journey less romantic than Lucian had hoped. In fact, he never fully engaged with his new 'career' as a seaman. Freud's most useful skill onboard ship may have been tattooing fellow sailors with India ink birds, hearts and arrows. He returned to London in the summer of 1941, abruptly ending his maritime adventure.

Freud spent the rest of the war taking classes at art schools, including Goldsmith's College in London, and moving in and out of different flats. Knowledge of the talented young artist began to spread among the city's art patrons and galleries. His first one-man show took place in 1944 at the Lefevre Gallery. Critics praised his "feeling for line … and for colour", and one of the paintings sold for £50. Lucian also began to accumulate an influential group of friends. He had a brief affair with Lorna Wishart, the glamorous and openly unfaithful wife of a London publisher. The two were often seen at clubs in Soho, along with other friends such as the painter John Craxton and the photographer John Deakin. Photographs of Lucian during this period reveal his youthful charisma, both charming and intense.

The end of the war presented Freud with more opportunities to satisfy his need for travel and exploration. Using funds from his benefactor Peter Watson, he travelled to Paris. The city had been liberated from German control only two years earlier, and Freud was keen to discover it and its culture for the first time. Using his growing connections in the art world, he socialised with a who's who of post-war painters and sculptors, including Pablo Picasso, Balthus, and Alberto Giacometti. After two months in the French capital, he made his way to Greece, spending time in Athens and the island of Poros. There, he and his friend John Craxton immersed themselves in the Mediterranean light and the local flora. A self-portrait from that trip shows Lucian with a sea thistle—in a surrealistic style somewhat like that of Greek-born artist Giorgio de Chirico.

Freud returned to England in early 1947. His art and personal life would soon undergo dramatic changes.

FAILED MARRIAGES AND GROWING FAME: 1947–1960

Lucian Freud was a captivating figure who combined good looks, nervous energy and supreme talent. He attracted romantic interest from both sexes, though his affairs were nearly always with women. Freud was often aggressive when initiating first encounters. One of his lovers, the author Joan Wyndham, described Lucian's advances at a party held in literary critic William Empson's house: "He was thin and hawk-like with hair growing low on his forehead and eyes that darted furtively from side to side. … After we had talked for a long time, he opened a trap door in the floor and took me down some rickety stairs to a nursery where Empson's children were sleeping. He pushed me back against Mogador's

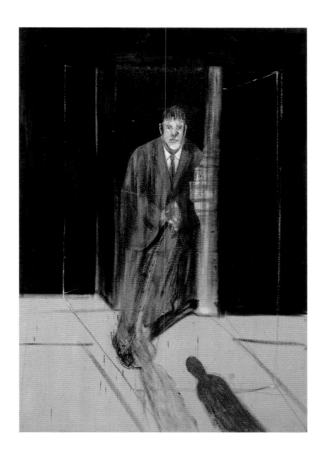

Francis Bacon, *Portrait of Lucian Freud*, 1951

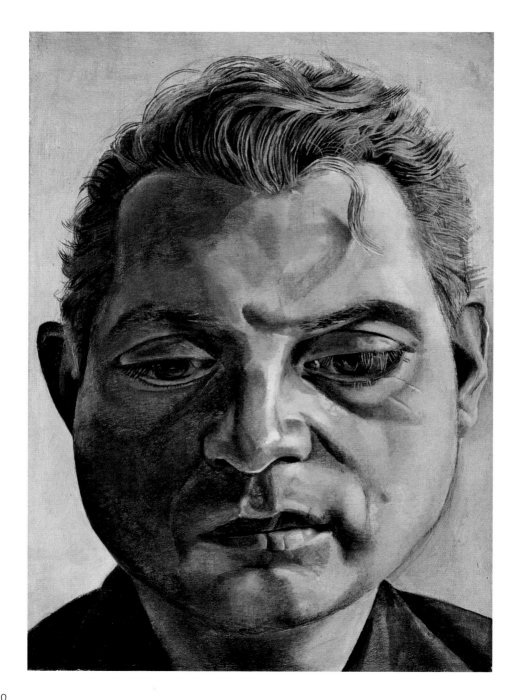

cot and kissed me, but Empson came down in a great rage and shooed us up again."

Such encounters, however, rarely led to long-term relationships. Lucian, in fact, was married for only a brief time in his life. His first wife, Kathleen (Kitty) Garman, was the illegitimate daughter of Jacob Epstein, a pioneering modernist sculptor. Kitty shared Freud's intense eyes, artistic inclination and nervous temperament. Lucian captured these qualities in a series of portraits from the late forties and early fifties—paintings that also mark a period of transition in his style. The earlier portraits of Kitty, such as *Girl with Roses* (1947/8, page 46), still show a stylised rendering of natural form. There is also a precise, linear quality to the composition that resembles Freud's early paintings of animal life, such as his double portrait of a squid and sea urchin from 1949. Freud later described his youthful art technique in an interview with William Feaver: "I set certain rules for myself and I suppose those rules were very exclusive. Never putting paint on top of paint. Never touching anything twice."

The 1950s, however, saw the artist beginning to evolve towards a new style and approach. In *Girl with a White Dog* (1950/1), Kitty Garman's body has been rendered with more depth and richness. Freud has started to focus on the undulating texture of skin, as well as the blemishes and imperfections that make the subject distinctive. Both Kitty and the Bull Terrier at her feet have a rounded fleshiness that is missing in *Girl with Roses*. The portrait also captures Lucian's wife in a more melancholy, resigned mood. Freud had never been faithful to Kitty, and now he was in a relationship that would put an end to his first marriage.

The new woman in question was a stunning, blonde-haired socialite named Lady Caroline Blackwood, the daughter of a marquess and an heir to the Guinness brewery fortune. Caroline was still a teenager when she first met Lucian at her coming-out party in 1949. This elaborate function featured a high society guest list, including Princess Margaret and Queen Elizabeth, the future Queen Mother. Freud was beginning to gain admission to London's elite circles, a social territory still off-limits for most British Jews. Lucian and Caroline would see more of each other at parties, often with the assistance of socialite Ann Rothermere, the lover and soon-to-be wife of James Bond author Ian Fleming. Ann desired the match for Lucian, and he and Caroline became romantically involved by 1951. Marriage would come in 1953, a year after Kitty sued Lucian for divorce.

Freud's social elevation coincided with more distinguished commissions. One of the most prominent involved the 1951 Festival of Britain, a nationwide fair that marked the centennial of London's first world's fair, the Great Exhibition of 1851. Lucian was among a handful of artists chosen to create a large painting for the fair's modern art exhibit. His contribution, *Interior at Paddington* (page 52), is another unusual double portrait—this time featuring Harry Diamond, a photographer and old friend of Freud's, and a

large potted palm tree. As in *Girl with a White Dog*, the artist displays his growing ability to depict surface textures and three-dimensional depth. The picture also evokes a sense of unease. Frumpily-dressed Diamond stands awkwardly by the wall, clearly upstaged by the aggressive-looking plant in the foreground. Freud here seems to expose the emotional uncertainty in British life after a devastating world war and a gradual loss of empire. Despite its pessimistic undertones, Lucian's work was among the top prize winners at the fair.

The fifties would also mark the heyday of Freud's relationship with the painter Francis Bacon. Like Freud, Bacon dedicated himself to exploring the possibilities of figural art in the twentieth century. His paintings often warped and twisted human figures into terrifying shapes. Bacon also re-imagined the works of the Old Masters, such as the baroque portrait of Pope Innocent X by Spanish artist Diego Velázquez. In Bacon's versions, the pope screams in agony while dissolving into a cage of vertical brushstrokes. Freud was captivated by Francis's emotionally-charged imagery, as well as his personal character. As he said in a 1992 interview with William Feaver, Bacon's "work impressed me but his personality affected me. [...] He talked a great deal about the paint itself carrying the form, and imbuing the paint with this sort of life. He talked about packing a lot of things into one single brushstroke, which amused me and excited me and I realised it was a million miles away from anything I could ever do. The idea of paint having that power was something which made me

feel I ought to get to know it in a different way that wasn't subservient."

One can see the stark difference in the two men's art through the portraits they made of each other at the beginning of the fifties. Bacon's portrait of Freud did not require Lucian's presence as a sitter, as it is based on a photograph of Franz Kafka that Bacon had in his studio. The work appears improvisational, with quickly-executed brushstrokes and lines defining space and form. The figure representing Freud is a vanishing ghost, a fleeting memory. Lucian's portrait of Bacon, however, is an entirely different affair. Freud painstakingly crafts the artist's face in close-up, making the fleshy skin look palpable and thick. He also captures some of the artist's personal complexity—a cocky outward assuredness mixed with deeper insecurity. Bacon, of course, submitted to hours of sitting for this work. Both portraits made their way into British museums, with Freud's work becoming a popular attraction at the Tate Gallery. *Francis Bacon* was stolen in 1988 while on exhibit at the Neue Nationalgalerie of Berlin, a museum close to Lucian's childhood home. Afterwards, Freud refused to let colour reproductions of the work be published—"partly because there was no decent colour reproduction, partly as a kind of mourning". The painting remains lost until today.

Lucian and Francis shared other passions outside of art. Both were inveterate gamblers, and it was Freud's gambling addiction that would strain his personal life later in the 1950s. Lucian's relationship with his brother Clement,

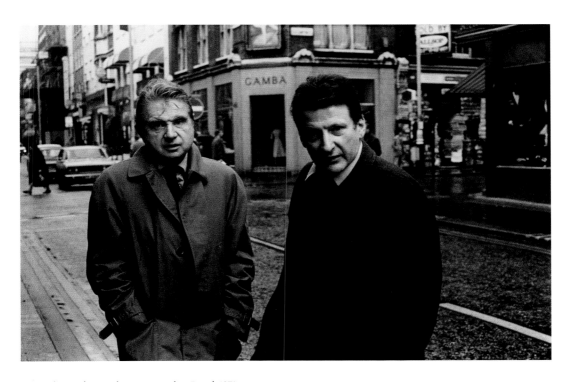

Harry Diamond, *Francis Bacon; Lucian Freud*, 1974

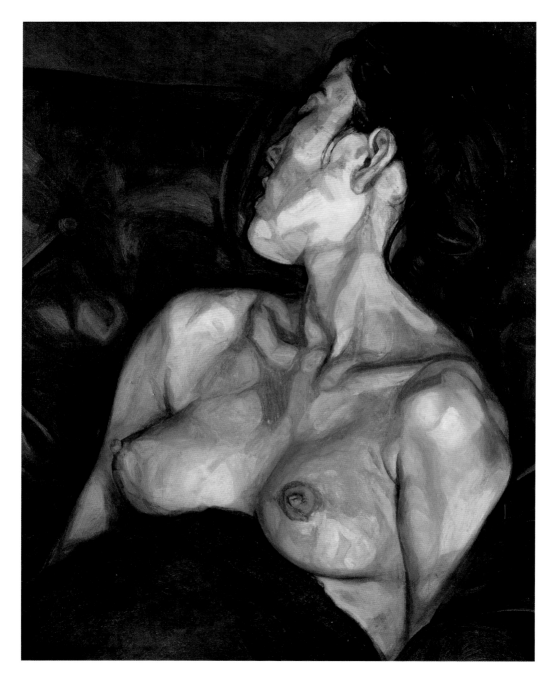

Pregnant Girl, 1960/61

which had never been close, was permanently ended in 1955 after Clement refused to extend him a loan to pay off gambling debts. Lucian's addictions also helped lead to the break-up of his marriage with Caroline. As she later said in an interview with Town and Country Magazine, "Lucian liked to gamble with Dostoyevskian passion. He played Russian roulette with everything; there was nothing he didn't take a risk on, and it was too much for his partner. Even in his driving, he had to overtake every blind corner, risking head-ons." Caroline would also admit that the two were simply "restless souls" that needed their freedom.

The couple separated in 1956, and Freud would never marry again. He would, however, have numerous other relationships with women—siring twelve or more children out of wedlock. Freud's friendship with Bacon would also become strained later in life. By the 1970s, they had become openly critical of each other's art. And though they were sometimes photographed together, the two would never regain the closeness they had enjoyed in the 1950s.

ARTISTIC TRANSFORMATION AND MATURITY: 1960–1990

As his second marriage was ending, Freud was growing increasingly dissatisfied with his work and painting technique. "I felt I'd got a method which was acceptable and that I was getting approval for something which wasn't of great account." Since his youth, the artist had used fine,

delicate sable brushes to achieve his precisely-rendered images. He had also followed the traditional method of sitting while studying his model and applying paint to canvas. But growing restlessness in his personal life, along with intimate exposure to the art and ideas of Francis Bacon, made him yearn for a freer method of working. This frustration can be seen visibly in a 1954 portrait called *Hotel Bedroom*. Freud depicts his young wife Caroline in bed with a prematurely-aged face and a fretful expression, while he stands next to the bed in shadow, hands in pockets, impatiently overlooking the scene. "My eyes were completely going mad, sitting down and not being able to move. Small brushes, fine canvas. Sitting down used to drive me more and more agitated. I felt I wanted to free myself from this way of working. *Hotel Bedroom* is the last painting where I was sitting down; when I stood up I never sat down again."

This change in working posture was only the beginning of a larger transformation in style and method. Freud replaced his "small brushes" with thicker hogs-hair brushes, which enabled him to apply paint more expressively. Then, in the early 1960s, Lucian returned to France and the Netherlands to study some of his favourite Old Masters, including Jean-Auguste-Dominique Ingres, Gustave Courbet and Francisco de Goya. Freud had long enjoyed museum excursions, but now the visits appear to have provided him with inspiration for his own art. He praised the "marvellous nude" in Courbet's *Les Baigneuses* (1853), a female bather shown from behind, her

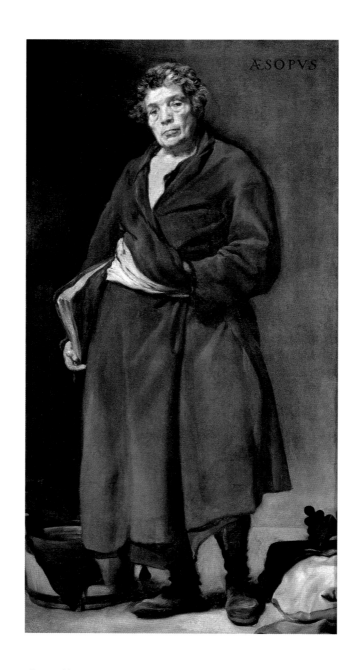

Diego Velázquez, *Aesop*, ca.1638

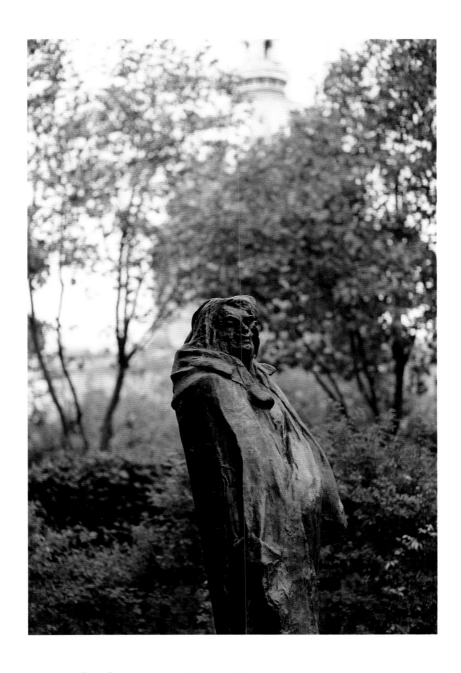

Auguste Rodin, *Balzac Monument*, 1892–7, cast 1939

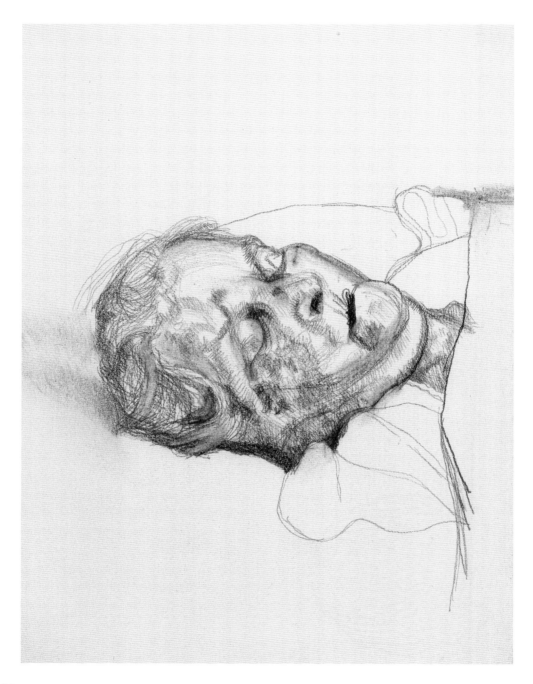

back and buttocks rendered with thick, rippling fleshiness. Lucian's paintings from this era begin to achieve a similar look. In *Pregnant Girl* (1960/61), a portrait of his then-lover Bernadine Coverley, Freud's brushstrokes can now be seen visibly on the model's skin and the couch upholstery. The artist also uses a greater variety of colours—purplish, pink, yellow and cream shades—to capture the undulating play of light. These details give the work a new fullness and sensuality.

Freud's fleshier style was not instantly admired by the British cultural establishment. During a 1963 exhibit, art historian Kenneth Clark wrote directly to Lucian to express his dismay over the new paintings. But this initial hostility and indifference did not put Freud off. His work would soon reveal an even more radical break from the past. In his portrait of photographer John Deakin (page 58), the face is composed almost entirely out of heavy, slashing brushwork. But rather than making the head look more abstract, Freud's technique achieves a rugged, earthy naturalism as well as capturing something of Deakin's inner character. This penetrating visage is somewhat reminiscent of works by Diego Velázquez, an Old Master admired by both Freud and Francis Bacon. In *Reflection with Two Children*, self-portrait (page 60), Lucian experiments with perspective and space. The foreshortened image of Freud looks downwards in an imperious manner, as though the viewer is trapped below him. Adding to the discomfort are two children painted at lower left, both of whom seem to exist outside the picture frame. Another major work from the sixties, *Large Interior, Paddington*, presents a composition reminiscent of *Interior at Paddington* from 1951. In the later work, the dishevelled, uptight figure of Harry Diamond has been replaced by a languid, reclining child with bare legs. Freud once again creates a double portrait of human and plant, but the dramatic perspective (this time the viewer looks at the scene from above), as well as the expressive forms and subtle play of light create a richly atmospheric look. Freud has given his art a warmth—a sense of place—that makes the work of his youth seem antiseptic by comparison.

Lucian would also broaden his concept of the portrait during this time. He began composing his so-called 'naked portraits' of the entire body (page 88). In an interview with William Feaver, Freud remarked, "I always started with the head; and then I realised that I wanted [...] the figure not to be strengthened by the head. The head is a limb, of course." Freud also explored 'portraits' of his urban neighbourhood in London's Paddington district. In *Wasteground with Houses, Paddington* (page 64), Freud transforms a rubbish dump outside his window into a breathing entity. As he described to William Feaver, "The rubbish dump was the feeling of not using a person. Like taking a very deep breath. I was very conscious as I looked out the window at the back that more and more people were leaving and it got emptier and emptier ... and somehow the rubbish was the life in the picture." Freud worked for several years on *Wasteground*, a painting that seems to

memorialise the bohemian world where he had worked for much of his life. It wasn't until 1977, five years after *Wasteground's* completion, that Lucian moved into an upscale area of London, taking a spacious, top-floor studio in Holland Park, Kensington.

Freud adorned his new studio with Old Master artworks. These included figures by French sculptor Auguste Rodin, who rendered the human body in bronze much as Freud was now doing in paint. Lucian was especially taken with Rodin's portraits of author Honoré de Balzac, in which the entire body is used to capture the spirit of its subject. Freud also began making works inspired more directly by Old Master compositions. *Large Interior, W11 (after Watteau)*, (1981–83, page 62) is based on a small painting called *Pierrot Content* (ca. 1712) by French artist Jean-Antoine Watteau. This same work is partially reproduced as background decoration in Freud's portrait of Baron Hans Heinrich Thyssen-Bornemisza (page 70). The Baron, one of Lucian's many illustrious acquaintances, owned the painting and would have it installed at the gallery named after him in Madrid.

The seventies and eighties marked a time of transition in Freud's personal life. His father, who had been a rather distant figure for Lucian, died in 1970. This event prompted Freud to make portraits of his mother Lucie in her old age. Freud was quoted as saying that he had to "overcome a lifetime of avoiding" Lucie in order to paint her. Since his childhood, Lucie had been a somewhat overbearing, stifling presence. But now, as she

was undergoing physical and mental decline and "losing interest" in him, Freud at last felt confident to study her in detail for the first time. The seventies portraits of Lucie often show a woman at peace, sitting in a chair or reading a book. As her health worsened, Freud depicted her lying helplessly in bed, her blank eyes staring aimlessly forward. The series of portraits ended with Lucie's death in 1989. Lucian drew his mother's dead face, with its mask-like coldness, in a way that hearkened back to his youthful pictures of dead animals.

THE FINAL YEARS: 1990–2011

With the death of Francis Bacon in 1992, Freud became the elder statesman of Britain's art world. But his productivity hardly ebbed during his final twenty years, despite losing full flexibility in his painting arm and suffering other discomforts of age. Lucian remained keenly interested in the bohemian side of British culture, and he began using underground celebrities as his models. The most famous of these was Leigh Bowery, an Australian-born performance artist who had founded London's Taboo club in 1985. Bowery became famous for his outrageous costumes, his openly gay lifestyle and his corpulent body.

Though not gay himself, Freud had long enjoyed the company of gay artists and art promoters, including Peter Watson and Francis Bacon. He and Bowery would become ideal partners in creating a series of remarkable portraits. Bowery's massive frame inspired Freud, with its

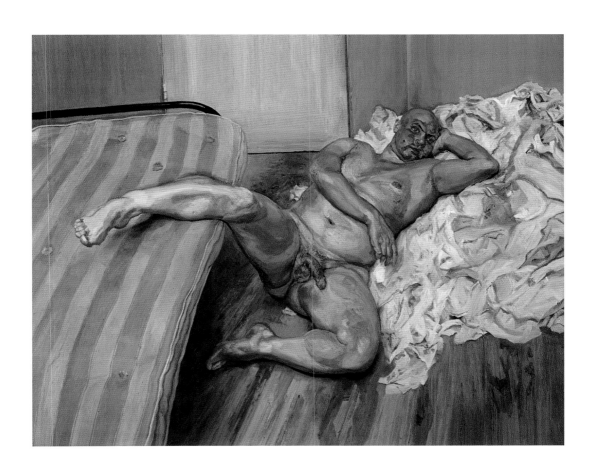

Nude with Leg Up, 1992

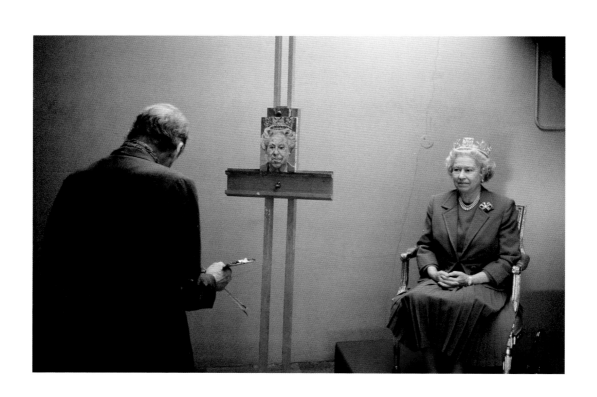

David Dawson, *Lucian Freud; Queen Elizabeth II*, 2001

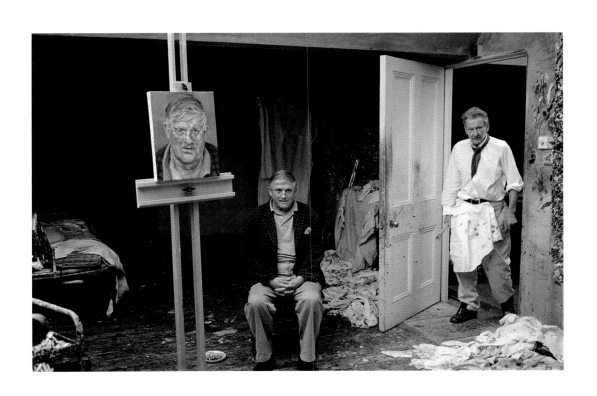

David Dawson, *David Hockney; Lucian Freud*, 2002

curves and folds that resembled the Baroque bodies in Peter Paul Rubens' art. Freud was also impressed with Bowery's athleticism and flexibility; his ability to pose in difficult positions. In an interview with William Feaver, Freud remarked that Bowery was always "moving around and trying different things. The (painting) with the leg up: I said, 'But surely that's not comfortable?' and he said, 'It really is.' [...] (He was) very aware, very relaxed and, well, curiously encouraging, in a way that physical presence can be. His feeling about clothes extends to his physiognomy even, so that the way he edits his body is amazingly aware and amazingly abandoned. Someone who wasn't a dancer couldn't move and relax as he does."

Bowery worked tirelessly with Freud for several of his last years, working daily "from, say, half past seven in the morning to five in the afternoon". The model and performer, however, kept the true state of his health from Lucian. Bowery had been diagnosed with HIV in the late eighties, and he succumbed to his illness on the morning of New Year's Day, 1995.

Lucian's experience with Bowery led him to paint other models of unusual proportions. 'Big Sue' Tilley was a government worker who spent nights at Bowery's Tattoo club, and Leigh introduced her to Freud in the early nineties. Soon, she became the female successor to Bowery in Freud's studio. In his most famous portrait of Tilley, *Benefits Supervisor Sleeping* (page 92), Freud gives her bulky features a sculptural power, somewhat resembling the Venus of Willendorf and other prehistoric images of female fertility.

Freud also continued to receive commissions from the social, artistic, and political elite, especially during the years around the millennium. He had long socialised with members of the royal family, and Queen Elizabeth II agreed to pose for him in 2000. Photographs of the artist and queen at work appear rather staid and formal, with pristine walls and elegant clothing. A similar photo was taken of another, very different sitting in 2002 with the British artist David Hockney. Though just as staged as the royal photo, this image shows the bohemian Freud at work, with rags strewn on the ground; rickety, dishevelled beds in the corner; and a general sense of messy inspiration. Neither image, however, truly conveys the intense, painstaking process of sitting for Lucian Freud.

Another millennium-era project brought Lucian's attention back to the Old Masters. For its *Encounters* project, London's National Gallery commissioned Freud to pick a work of art in the collection and create his own variations of the picture. Freud chose Jean-Baptiste-Siméon Chardin's *The Young Schoolmistress*, a delicately rendered genre painting of a chubby child and his angelic young teacher. Freud made several versions of the scene, some in paint and some as etchings. One of the etchings takes Chardin's graceful, light-dappled forms and gives them a rougher, earthier solidity. In some ways, this transformation resembles the one Freud made with his own art in the 1950s and 1960s.

In the last decade of his life, we see Freud's brushwork become increasingly thick, especially

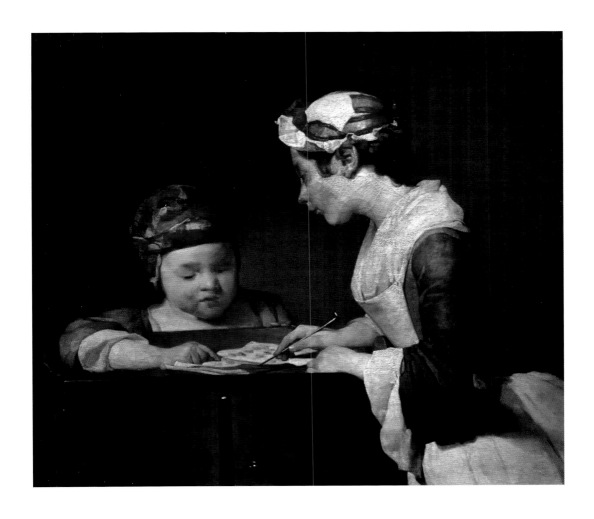

Jean-Baptiste-Siméon Chardin, *The Young Schoolmistress*, ca.1735/6

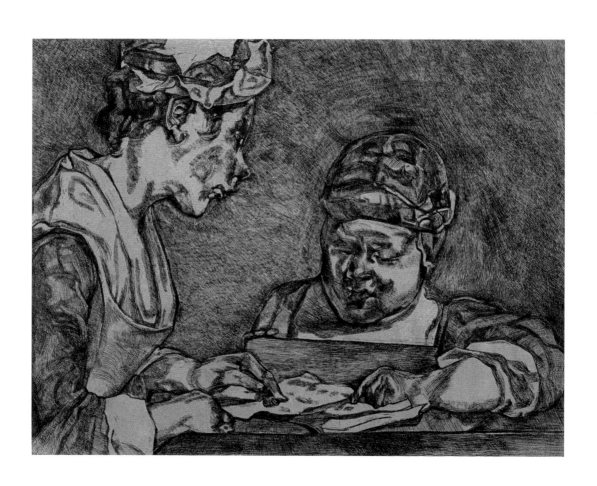

After Chardin (etching), 2000

36

when rendering faces. In Lucian's 2002 self-portrait, his facial features appear blurred, as though he is urging his viewer to notice the paint itself as much as the image created by it (page 104). Lucian's brush is kinder to images of horses, dogs and gardens, which become more prominent in the late 1990s and 2000s (pages 95 and 109). These works are a world away from the taxidermic paintings of Freud's youth. Paws, hooves and tails; branches, stems and leaves all quiver with life. When Lucian's own life came to an end on July 20th, 2011, he left a painting of his long-time assistant David Dawson unfinished (page 109). Britain's great portraitist had never stopped travelling on his artistic journey.

WORKS

Cedric Morris, 1940

Oil on canvas
30.5 × 25.4 cm
National Museum and Gallery of Wales, Cardiff

"I don't mean when I look at early things I think they're ignorant, so much as much
more limited. But then I was obviously much more limited, or very different, and I
felt I had much less freedom than I have now. ... There's a certainty they were more
willed, but in an inflexible way."
(Lucian Freud on his early artworks, from a 1988 BBC interview with Jake Auerbach)

Lucian Freud escaped from Nazi Germany in 1933, beginning a somewhat chaotic
period in his youth. He was expelled from several art schools in the late thirties,
partly for violent behaviour and partly because he couldn't tolerate the strict teach-
ing methods that were common at the time. It wasn't until he found Cedric Morris's
East Anglia School of Painting and Drawing that he found a real artistic home.
Cedric Morris (1889–1982) was a talented portraitist and flower painter who, with his
partner Arthur Lett-Haines, founded the East Anglia School in Devon. Unusual
for its time, it was conceived as a relaxed, country retreat where young artists could
explore their own creativity without formal teaching and without long-term com-
mitments to the school. Its format was perfect for Lucian, who took to the school
immediately. One of Freud's oldest surviving works from this time is a portrait of
Morris. Lucian, who was still a developing artist with "limited" technique, presented
his mentor in a somewhat joking manner, with a pirate-like, one-eyed stare and a
pipe in his mouth. It's an image of youthful irreverence that also reveals Freud's
admiration for Morris, as he adopts his mentor's flattened, expressionistic style.
Freud would also emulate Morris's deliberate painting technique, as well as his pen-
chant for cravats.

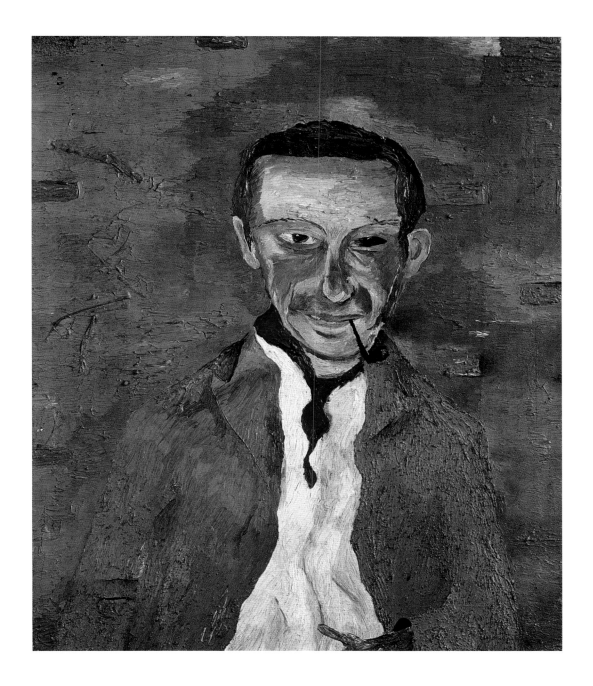

The Village Boys, 1942

Oil on canvas
50.8 × 40.6 cm
Private collection

This work, painted at the end of Freud's time at the East Anglia School of Painting and Drawing, represents one of his first attempts at double portraiture. Lucian would spend the rest of his life exploring how to present two contrasting figures in provocative ways. Over time, Freud's double portraits would include animals and plants, as well as human beings.

The two boys here were probably drawn from life models. They stare ominously outward, surrounded by artwork that might have appeared in Morris's studio. The larger boy adopts a somewhat aggressive look, glowering directly at the viewer, while the other glances wistfully to his left. A certain emotional tension pervades the scene, which Freud achieves, in part, by playing with scale. The larger boy's massive head contrasts eerily with his tiny, wispy hands; while the smaller child resembles a marionette that has been placed on the ground. Freud's elaborate, off-kilter composition is worlds away from the naive simplicity of *Cedric Morris*. The large, almond-shaped eyes in Freud's early work come from two sources: the paintings of Cedric Morris and a book of ancient Egyptian portrait busts that Lucian had been given a few years earlier. Eyes, in fact, appear throughout *Village Boys*, dominating the scene. Freud himself was known to have an intense stare when he observed his sitters. *Village Boys* also suggests, with its somber brownish and grayish hues, the weariness of wartime Britain. London and the rest of the country had been suffering under Nazi attacks for two years, and it would take another three before peace would finally arrive. The dull-coloured boys in this image seem almost grubby—"very weedy" and "strange", (see Further Reading on page 110, William Feaver, 2002) according to the artist—and weighed down by the gravity of their times.

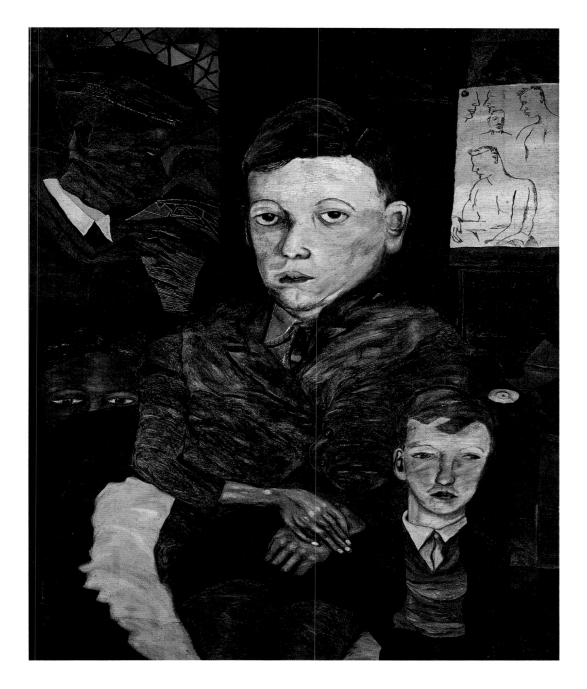

Quince on a Blue Table, 1943/44

Oil on canvas
36.8 × 58.4 cm
The Lambrecht-Schadeberg Collection, Siegen

Lucian Freud held his first one-man show at the Lefevre Gallery in London in 1944. Founded in 1871, the Lefevre had championed contemporary art for decades in a country not always accepting of modern work. Paintings of Henri Matisse, Pablo Picasso, Georges Braque and Salvador Dalí had been featured in shows as early as the 1920s. But wartime had dampened and nearly ended the gallery's activities. In 1943, the Lefevre's building on King Street was destroyed by German air bombs, and it wasn't until late 1944 that the gallery opened new quarters on New Bond Street. Freud's show would be one of the first exhibits there.

Lucian's works did get reviewed by critics, who offered muted praise for their "youthful mannerisms" and "natural feeling for colour" (see Further Reading on page 110, Sebastian Smee, 2005). Freud also managed to sell one of the paintings for a reasonable sum. Entitled *The Painter's Room*, this quirky still life featured a red-and-yellow striped zebra sticking its head into an oddly-furnished, bare-walled room. The picture's surrealistic look may have played a role in its £50 selling price, as surrealism was enjoying international popularity at the time.

Freud, however, rejected the surrealist label for himself. He was not interested in that movement's taste for contorted natural forms and odd juxtapositions, nor its search for subconscious insights. Freud, in fact, wasn't interested in being part of any artistic movement. He intended his works to convey reality as he saw it. In *The Painter's Room* and a similar work entitled *Quince on a Blue Table*, shown here, the artist arranges objects from his own life as an exercise in composition. The zebra head that dominates both works was painted directly from a taxidermised head that Freud received from Lorna Wishart, a woman who would become his first and most ardent romantic obsession. *Quince on a Blue Table* also features fruits and plants, organic objects that reveal the painter's interest in biology and may also suggest the passions of an amorous twenty-something.

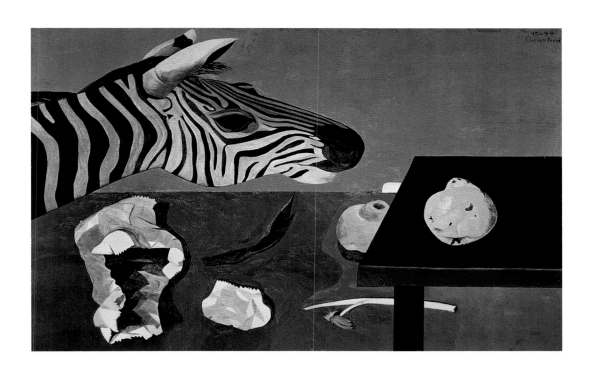

45

Girl with Roses, 1947/48

Oil on canvas
105.5 × 74.5 cm
The British Council, London

Kathleen Eleonora (Kitty) Garman came from an artistic but complicated family. Her parents were Jacob Epstein, then Britain's leading modernist sculptor, and Kathleen Ester Garman, Epstein's mistress. The young Kitty spent little time with her natural mother, as she was raised in rural Herefordshire by her grandmother, Margaret. But the young girl was not completely isolated from her famous father, who along with her grandmother instilled in her a love of art. Kitty was a student at London's Central School of Arts and Crafts in 1946, when her aunt, Lorna Wishart, introduced her to Lucian Freud at the Café Royale. The meeting would lead to a fruitful artistic partnership and a brief, unhappy marriage.

In many ways, Kitty was an ideal sitter for Lucian in the late forties. She had the striking, wide-eyed look that Freud preferred in his early works. She also had experience modelling for her father's sculpted portraits, which helped her endure the marathon sitting sessions that her new partner required. For many art historians, *Girl with Roses* is Freud's first great masterwork. In its tightly-rendered composition, he seamlessly merges girl and chair into a single, expressive form, using minute detail to create surfaces that look almost photographically realistic, from the soft folds of the fabrics to the finely delineated strands and curls of hair. In each of Kitty's eyes, Lucian adds the reflection of a sash window, suggesting that the girl's focus may be outside the confines of the space portrayed. Kitty's eyes also suggest anxiousness and melancholy, feelings that seem echoed in the 'peace roses' in her hand and on her lap. Overall, Freud's beautiful image has the feel of an Old Master painting. The ivory-like skin, with only a single discoloured patch on the right hand, resembles the Tudor portraits of Hans Holbein the Younger, another German-born artist who worked in London.

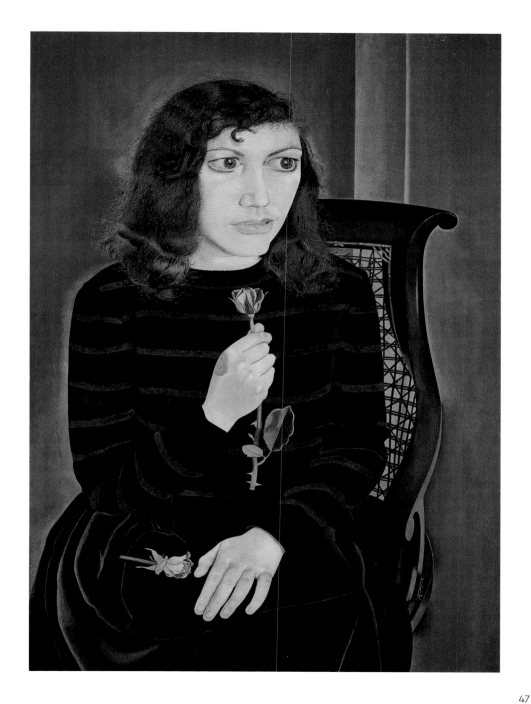

Head of a Woman, 1950

Oil on copper
20.4 × 14.5 cm
The Devonshire Collections and the Chatsworth Settlement Trustees, Derbyshire

"I remember quite long ago wondering why, when painting heads, I used to be so affected by where the sun had got their necks and changed the colour of the skin and trying to get that. I am inclined to think of (sitters) as naked or, if they are dressed, as animals dressed up. So that isn't the end of the neck, it's the end of the nakedness that I'm painting when I start the clothes. I want the person looking to see not 'who's in that blue shirt?' but 'who's that? Oh, they're wearing a shirt.' Which is different, isn't it?"
(Lucian Freud from an interview with William Feaver)

Freud's portraits began to undergo significant changes in the 1950s. This painting shows Lucian beginning to render human skin in a less pristine manner. Wrinkles and undulations, as exposed by sunlight, are highlighted by the artist's bolder use of colour and shade. The finely-detailed smoothness of texture seen in *Girl with Roses* is replaced by an earthier naturalism, with features like the nose and chin given a newfound sculptural weight, and the hair shown slightly dishevelled. Even the woman's expression seems to have greater depth and maturity. Freud is beginning to paint his subjects as adult women and men.
The sitter for this work is Lady Elizabeth Georgina Alice Cavendish, the daughter of Edward Cavendish, Duke of Devonshire, and an intimate associate of the royal family. Only a few years before this painting was made, she had begun her nearly lifelong service as lady-in-waiting to Princess Margaret, sister of the future Queen Elizabeth II. Freud was also an acquaintance of the princess, one of many connections he would acquire in the world of British high society.

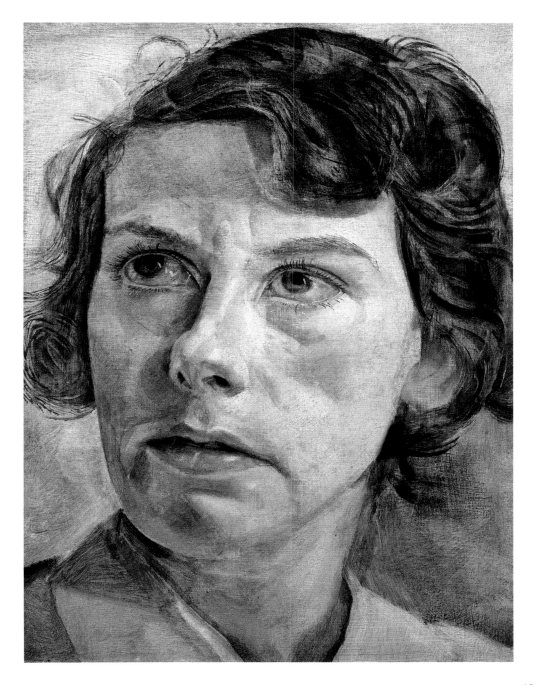

Girl with a White Dog, 1950/51

Oil on canvas
76.2 × 101.6 cm
Tate Gallery, London

"To me, the earlier paintings show my mother as a girl. And then you turn to this
(*Girl with a White Dog*), this is a painting of a woman. And there is a much greater
sense of self projecting at you, the viewer. There's a sense of sadness and some
anger, I think. It's to do with real life, the maturation of her face. There's a much
more complicated person being portrayed here. There are thoughts and emotions
and a life going on, and the nature of her gestural self is richer and more complex,
with her hand on her breast and the other resting on the mattress. And also a huge
part of the painting is taken up with this yellow, towelling dressing gown. And it
somehow adds a difficult emotional aspect to the painting, its ... complex folds and
the way it goes so deeply in at the waist."
(Annie Freud on her mother Kitty's portrait in *Girl with a White Dog*, from the 2012
documentary film *Lucian Freud: Painted Life*)

The marriage of Kitty and Lucian may have begun happily, but it was doomed to be
short-lived. Freud continually sought stimulation from new encounters and relation-
ships, and he began to have affairs almost immediately after his wedding in 1948.
The first of these relationships was with Anne Dunn, an artist and teenaged daugh-
ter of a wealthy industrialist. Anne found Freud to be "pulsating with energy" (see
Further Reading on page 110, Geordie Greig, 2013, page 92) and the two spent a
month together in Ireland during the early years of Lucian's marriage. Then around
1951, Freud would start an even more serious affair with Caroline Blackwood, a
wealthy heiress.
Lucian was often protective of the secrets in his personal life, but his portraits
rarely hide the truths about their sitters. *Girl with a White Dog* shows much of the
resignation and pain that Kitty felt during this period in her life. As their daughter
Annie Freud would later discuss, Freud captures Kitty's mood not only in the face,
but also in the "complex folds" of her clothing. Even the muscular bull terrier
appears to be offering emotional comfort to his mistress. Lucian and Kitty would
divorce around a year after this painting was completed.

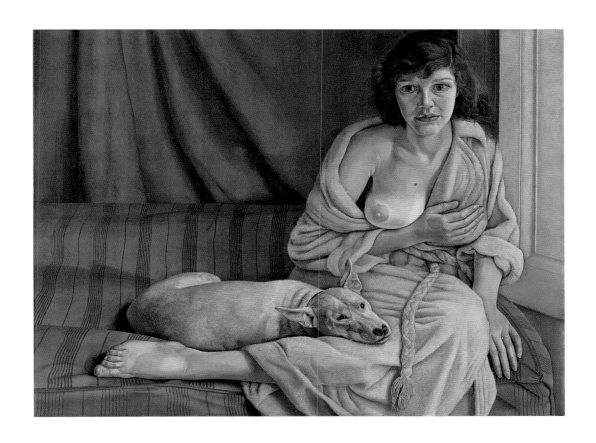

51

Interior at Paddington, 1951

Oil on canvas
152.4 × 114.3 cm
Walker Art Gallery, Liverpool

"He said I made his legs too short: the whole thing was that his legs *were* too short. He was aggressive as he had a bad time being brought up in the East End and being persecuted."
(Lucian Freud on Harry Diamond, from an interview with William Feaver)

World War II ended in 1945 with an allied victory and the preservation of Britain's independence. But the fruits of that victory were not fully felt in London for many years. Rationing of food and other items lasted until the early 1950s, helping to mire the British public in a post-war malaise. To lift its nation's spirits, the Labour government under Prime Minister Clement Atlee held a festival in 1951. This Festival of Britain also marked the centenary of London's Great Exhibition of 1851, the first world fair ever held. But the new fair would not be an international event; it would instead focus on Britain's own achievements in industry and culture. As part of the festival, an exhibition of sixty large paintings was commissioned from leading British artists by the National Arts Council. Freud, who was among the chosen artists, contributed *Interior at Paddington*.

This double portrait was Lucian's first publicly commissioned work, and by far his largest to date. Freud's fastidious attention to detail, his photographic rendering of surfaces and his ability to portray the muted light of his home city are all on display here. But despite its size, the canvas depicts an intimate, almost claustrophobic scene of man and plant. The standing man, with his ill-fitting clothes and awkward stance, seems drained of energy and somewhat intimidated by the spiky potted plant. There is an almost arid quality to the room, which appears blocked off from the outside world by the window and iron railing. Outside, we see the hazy world of Paddington, a rather grubby London district that artists like Freud were beginning to use for their studios.

Harry Diamond, the model for *Interior at Paddington*, was a friend of Lucian's who came from the working-class Jewish community in London's East End. He complained to Freud about the way he was portrayed, as well as the tortuous painting sessions that required him to stand for hours a day over the course of six months. These efforts helped Freud win one of the top prizes from the Arts Council—an award of £500.

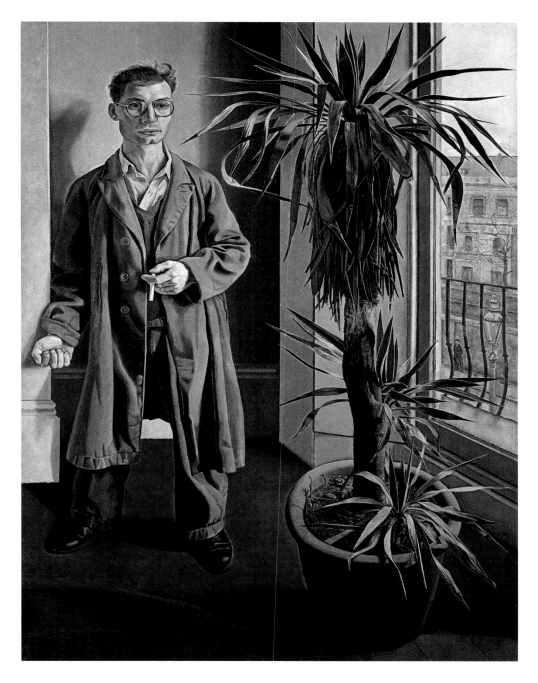

Bananas, 1953

Oil on canvas
22.8 × 15 cm
Southampton City Art Gallery, Southampton

Among Lucian Freud's illustrious acquaintances were Ian and Ann Fleming. Ian had worked in British naval intelligence during World War II, and he would use his knowledge of spycraft to write the famous James Bond novels. Ann, an earl's daughter, was a leading socialite who helped introduce Freud to many in her aristocratic circle. It was she who helped encourage an affair between Freud, then married to his first wife Kitty, and the wealthy Guinness brewing heiress Caroline Blackwood. Kitty would divorce Lucian in 1952, and Freud and Caroline would elope later that year—the same year Ian Fleming published his first Bond story, *Casino Royale*.
At the end of 1952, Freud was invited by Ann and Ian to stay with them at Goldeneye, the couple's new villa in Jamaica. Always eager to travel, Lucian accepted the invitation, though limited finances forced him to travel on a banana boat across the Atlantic. Lucian to that point had spent little time in tropical climates, and he took the opportunity to observe and capture his surroundings. Freud was fascinated by the plant life he saw there, and he went on several open-air painting sessions. One of his Jamaica images featured a bunch of bananas still growing on a tree and surrounded by verdant tropical foliage. The fruit and leaves curve sensually across the canvas, swelling with fertile energy. Freud's image, still in the stylised mode of his youth, is reminiscent of the voluptuous flower paintings of Georgia O'Keeffe. As his work technique and sensibilities evolved, Lucian would continue to explore the rich textures, forms and internal energy of plants.

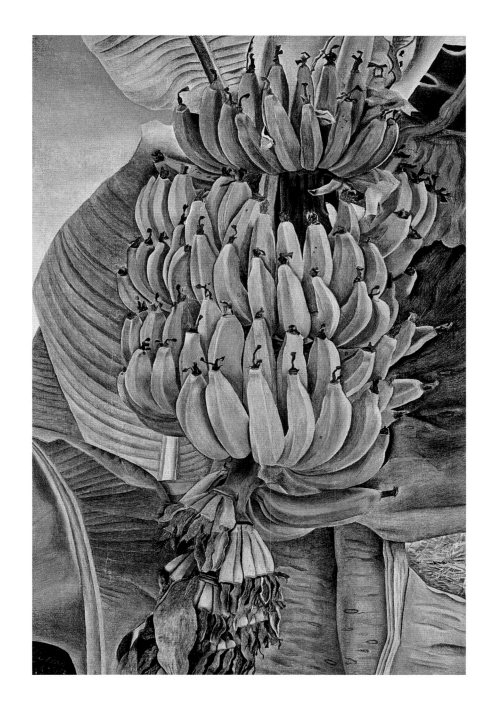

Man's Head (Self-Portrait III), 1963

Oil on canvas
30.5 × 25.1 cm
National Portrait Gallery, London

"I know my idea of portraiture came from dissatisfaction with portraits that resembled people. I would wish my portraits to be *of* the people, not *like* them. Not having a look of the sitter, *being* them. I didn't want to get just a likeness like a mimic, but to *portray* them, like an actor. ... As far as I am concerned the paint is the person. I want it to work for me just as flesh does."
(Lucian Freud from an interview with Lawrence Gowing, 1980s)

Lucian Freud referred to his art as autobiographical, so it's not surprising that he created numerous self-portraits throughout his career. One can use these works to document the evolution of his style over seventy years. Freud's early art had a renaissance-like clarity and wealth of detail, created by the use of fine sable brushes and the sensibilities of an amateur biologist. In the 1950s, however, he began to be "affected" by conversations with fellow painter Francis Bacon, who talked of "the paint itself carrying the form" and "packing a lot of things into a single brushstroke" (both quotations from an interview with William Feaver in 1992). Freud was also undergoing a personal mid-life crisis after two failed marriages. His response to these factors was a remarkable period of experimentation and change in his art making.
This sketchy self-portrait is an excellent example of Freud's stylistic transition. Now using thicker hogs-hair brushes, he began laying down paint with heavy brushstrokes, in which the bristle marks can be clearly distinguished on the surface of the canvas. The result here is almost cubist is style, with the facial features somewhat obscured and abstracted. It represents the first step in a process that would lead to a richer, more sculptural style that Freud made all his own.

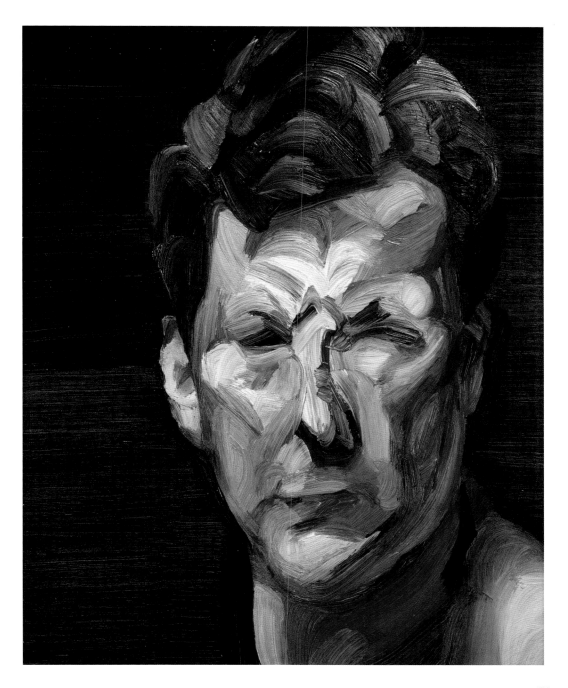

John Deakin, 1963/64

Oil on canvas
27.9 × 24.7 cm
Private collection

"Being fatally drawn to the human race, what I want to do when I take a photograph is make a revelation about it. So my sitters turn into my victims."
(John Deakin on his portrait photography)

The hard-drinking, sardonic John Deakin was an important member of Freud's artistic circle in post-war London. From 1947 to 1954, he worked for brief periods as a staff photographer at the British *Vogue* magazine, though he was never satisfied with fashion photography and often ridiculed his co-workers there. One of his unpublished *Vogue* portraits from 1952 featured Lucian Freud, and it typifies Deakin's style. The painter's face is captured in close-up, with the wide-eyed gaze he would often use when examining a sitter. Deep shadows hide parts of the mouth and eyes, and the overall effect is one of disturbing aggressiveness. Starkly revealing images such as this one would make Deakin a well-respected portraitist of the cultural avant garde and London street life.

Deakin also played an important role in the work of Lucian Freud, who had been finding it difficult to work with and direct live models in his studio. "When Francis (Bacon) found John Deakin", Freud would later say in an interview, "he got John Deakin to photograph these people in particular positions, and that helped Francis enormously". Bacon produced many of his finest works from photographs he commissioned from Deakin.

Freud portrayed John Deakin in the early sixties, around the time he was working for Bacon. The image reveals some of Deakin's rough-edged personality. But the course face is softened by a wistful, rather pleading look in the eye. Freud was continuing to experiment with thick brushwork and bolder modelling, and his new style was beginning to capture more effectively the inner life of his sitters.

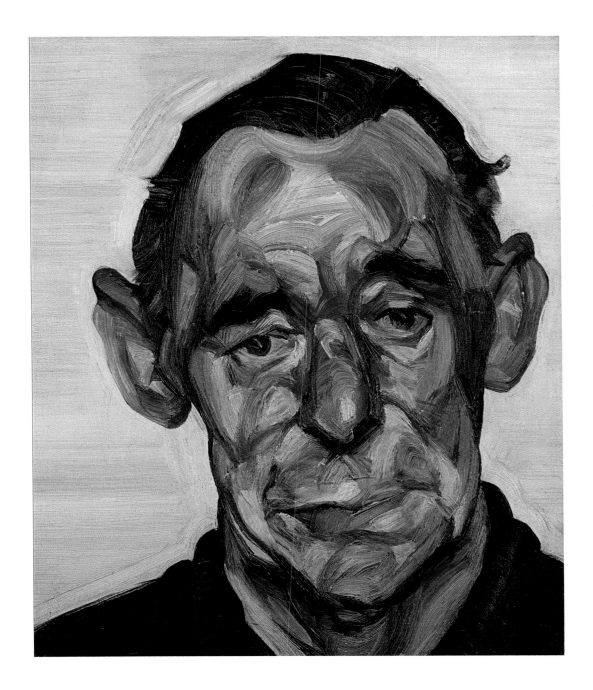

Reflection with Two Children, Self-Portrait, 1965

Oil on canvas
91.4 × 91.4 cm
Thyssen-Bornemisza Collection, Madrid

Freud's artistic transformation at this time involved more than experiments with brushwork. He also explored daring new compositional techniques. This work creates the appearance of two separate spaces. Freud depicts himself foreshortened and looking downward at his audience. His rather haughty expression, along with the starkly modernist lamps above him, give the viewer a sense of being examined, as if on a couch or in a hospital clinic. The painting also resembles an image one would see in a mirror. Freud, in fact, included the word 'reflection' in the title—as he would in many of his later self-portraits.

At lower left, we see figures of a laughing boy and quizzical girl who are separated from the painting's main space by what looks like a wooden railing or the bottom of a picture frame. The children appear almost as fellow spectators, who have turned away from the image and are now noticing the rest of the audience. Freud heightens the feeling of unease in the way he renders the children's faces, using reddish and crème brushstrokes to give them a strange, almost menacing look.

The models for the girl and boy were Rose and Alexander (Ali), two children he had with Suzy Boyt, one of his students from the Slade School of Fine Art in London. Freud taught at the school off and on for several years beginning in 1949, and he began his affair with Suzy in the mid-fifties, at the end of his marriage with Caroline Blackwood. Freud historians note that the placement of the children was inspired by an ancient Egyptian sculpture Lucian found in his book, *Geschichte Aegyptens*. The painted sculpture, which dates from about 2520 BC, features an Old Kingdom official named Seneb and his wife on a throne-like stone block. Two children stand below the father, their bodies disproportionately tiny. In both the ancient sculpture and in Freud's twentieth-century reworking, we perceive a complex relationship between parent and child—a struggle between emotional connection and separation. Lucian would later proclaim himself, in sardonic fashion, "one of the greatest absentee fathers of the age".

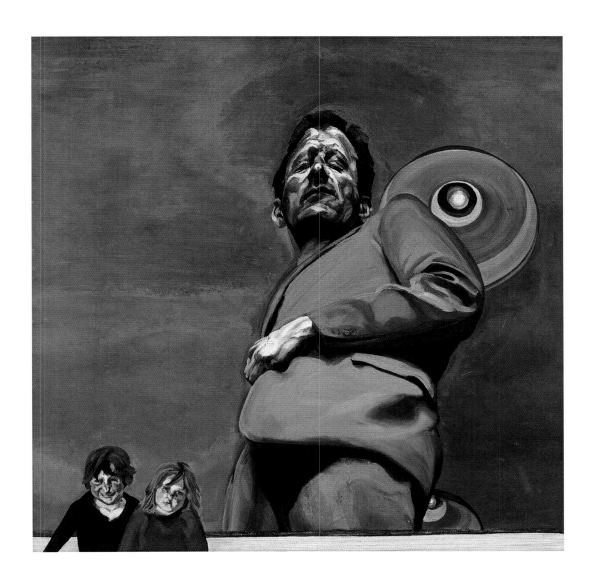

Large Interior, Paddington, 1968/69

Oil on canvas
182.8 × 121.9 cm
Thyssen-Bornemisza Collection, Madrid

"I realised from an early age what he was about, that he drank, slept and breathed paint."
(Susie Boyt on her father, Lucian Freud)

Freud continued his mid-career exploration of space and composition in this large work featuring his daughter Isobel (Ib), Lucian's third child with Suzy Boyt. The viewer is given a somewhat domineering view into the quiet indoor scene. Ib's resting body, with its dishevelled hair and naked lower half, is entirely vulnerable—only partially protected by the spreading, twisting branches of the potted plant. The artist's frumpy jacket hovers over the child, a less obtrusive replacement for the imperious father in *Reflection with Children*, *Self-Portrait*. And as with this earlier work, Freud achieves visual energy by using multiple perspectives—the walls and plant rise in slightly different directions.

One can see Freud's evolution as a painter by comparing this image to his first large-scale portrait of a person and plant, *Interior at Paddington* (1951). The earlier work had been characterised by a pristinely-detailed rendering of surfaces, as well as an underlying emotional cynicism. It reflected the buttoned-up London of the early fifties. But the post-war era of rationing and self-denial was long gone by 1968, when Freud began *Large Interior, Paddington*. The latter work seems to have a laid-back, hippyish character, without needing to incorporate any specific cultural references from the sixties. Freud's expressive brushstrokes and soft, natural play of light imbue the scene with a casual, lived-in sense of place.

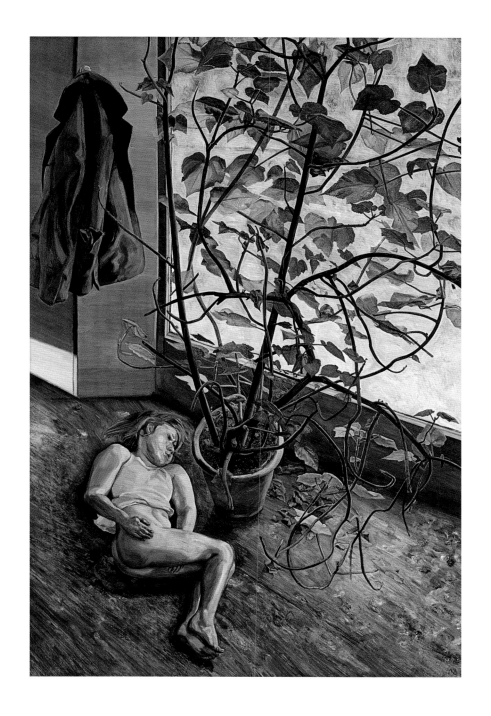

Wasteground with Houses, Paddington, 1970–72

Oil on canvas
167.6 × 101.6 cm
Private collection

"I stayed in that first house for years and then I moved to another house in the same street, then to another nearby. Eventually, they were bought up by the council, which kept warning me that I was not a unit—a unit being a family with young children, or an old retired person. So I was put in buildings that were scheduled to be demolished, which suited me fine. I remember that once I was the last person left living in a long street, and the demolition men got closer and closer. I was working on a painting in the studio. In the end I passed down some whisky bottles and they agreed to let me have another couple of days. It seemed important at the time."
(Lucian Freud from a conversation with Martin Gayford, 2003)

Freud spent years living in the bohemian streets of Paddington. Artists of his day often took cheap apartments in the area by necessity, as it was the only way they could afford to establish a working studio. Lucian, however, who was born into a prominent family and courted the attention of aristocrats and cultural leaders, seemed to prefer living in an area apart from London's bourgeois formality. The rough edges of Paddington could often stimulate his creativity, especially in this remarkable urban 'portrait', taken from a wasteground outside the back of his apartment at Gloucester Terrace.

When Freud began this picture in 1970, he had little experience painting urban landscapes. *Wasteground,* however, became something of a personal project for him over the next two years, with Freud constantly refining and modifying the image. He experimented with adding human figures, but ultimately decided the work should focus on the rubbish dump itself, with its scruffy vegetation, broken furniture, and twisted scraps coalescing into a kind of organic stew. Windows, chimneys and garage doors surround the bubbling waste, and seem to shelter it. Freud conveys a sense of comfort in this decaying world—a world he would leave only a few years after *Wasteground* was completed.

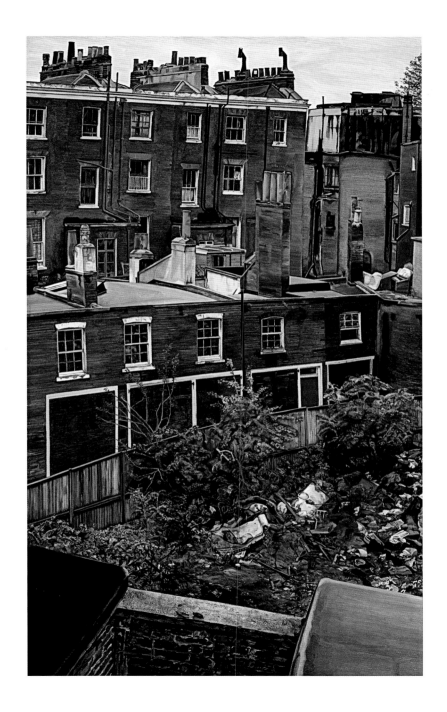

The Painter's Mother IV, 1973

Oil on canvas
27.3 × 18.6 cm
Tate Gallery, London

"If my father hadn't died I'd never have painted her. I started working from her because she lost interest in me; I couldn't have if she had been interested. ... I had to overcome a lifetime of avoiding her. From very early on she treated me, in a way, as an only child. I resented her interest; I felt it was threatening. She was so intuitive. And she liked forgiving me; she forgave me for things I never even did."
(Lucian Freud on his mother, Lucie, from interviews with William Feaver)

Freud had an often-strained relationship with his parents. He struggled against both his father Ernst's indifference and his mother Lucie's suffocating attention. When Ernst Freud died in 1970, Lucie began to suffer from a depression that eventually led to mental decline. The woman who had been "vivacious" (see Carola Zeitner below) and "aggressive" (see Further Reading on page 110, Phoebe Hoban, 2014) and frustrating to Lucian was now mellowed and less able to shower her son with unwanted pampering.
Lucian portrayed his mother more than a dozen times beginning in 1972, creating an extraordinary record of Lucie's gradual decline and eventual death in 1989. In the version shown here, now displayed at the Tate Gallery, Freud captures his mother's profound sadness in the downcast expression and in the muted grey and brown colour scheme. Lucie's face is made to stand out by the way Freud uses complimentary methods of applying paint. The background is applied smoothly over layers of primer. To create his mother's face and hair, Lucian uses thick, sinuous impasto brushwork. Later portraits of Lucy would show her in a reclining position with an increasingly disengaged look. The last image in the series would show her dead face, a mask-like drawing done in charcoal (page 28).
Freud's relatives were not always appreciative of the portraits of his mother. Lucian's cousin Carola Zeitner felt he exploited Lucie's declining condition, saying "What he revealed was despair and grief and I who loved her as a wonderful, vibrant, vivacious, bright individual hate seeing this particular view of semi-mortality, because basically she was still alive physically but she really wasn't alive mentally." Lucian, however, believed that the painting sessions often improved her mental state.

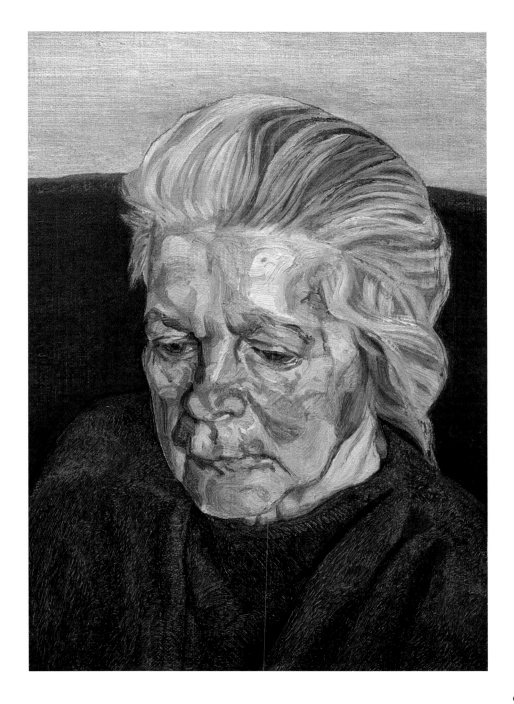

Small Naked Portrait, 1973/74

Oil on canvas
20.3 × 25.4 cm
Ashmolean Museum, Oxford

"...I want the naked body to add information to the whole portrait. Sometimes I'm concerned with using something that's in them, in their head or whatever, and which isn't actually visible, so that I have the information which will help the picture. And in turn, to find out more: things which I wouldn't see immediately, in one look, ..."
(Lucian Freud from an interview with William Feaver, 2007)

Until the 1960s, Lucian worked mostly with clothed models. But as he often stated in interviews, Freud approached the human body as an animal—an animal that may be hiding part of its nakedness in clothing. This attitude gradually led him to experiment with the idea of a nude portrait, where the personality of the sitter is expressed in the entire body, not just the face.

The body portrait shown here, which dates from the early seventies, relies on the nimbleness of its model, Jaquetta Eliot. One of Freud's many lovers during this period, Jaquetta was the daughter of a baron and the wife of an earl. She was hot-tempered and quick-witted, and she had a somewhat tumultuous affair with Lucian that lasted off and on for nearly a decade. For Eliot, Lucian's appeal was "feral" and "fantastically intimate" (see Further Reading on page 110, William Feaver, 2007, page 24). She, in turn, satisfied Freud's taste for aristocratic companionship and a free-spirited attitude. Lucian portrayed Jaquetta many times. In one of the more disturbing images, a naked Eliot is shown reclining behind Freud's solemn mother. The painting we see here is somewhat less provocative. Lucian depicts Jaquetta in a semi-fetal position with closed eyes, yet the intensity of her character shows through in the vibrant brushstrokes that make up her legs, arms, face and hair. A pulsating energy flows through the body, which seems ready to spring forward when awakened.

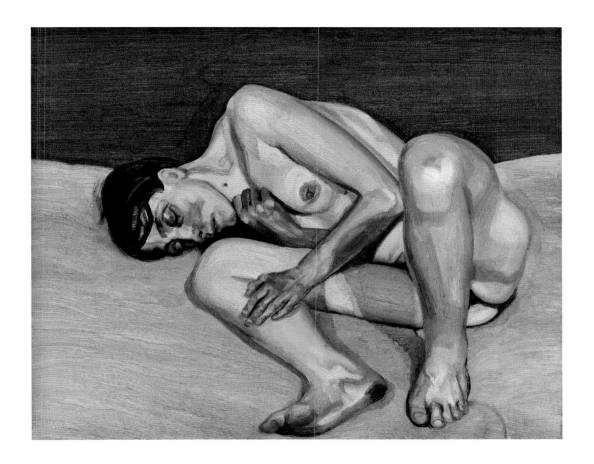

Portrait of a Man
(Baron H.H. Thyssen-Bornemisza), 1981/2

Oil on canvas
51.1 × 40.8 cm
Thyssen-Bornemisza Collection, Madrid

In 1947, Baron Hans Heinrich Thyssen-Bornemisza inherited his father's banking and industrial empire. He also received his family's vast art collection of Old Master paintings, the largest European collection then in private hands. Over time, Baron 'Henri' added modern art to his holdings, including works by Emil Nolde, Pablo Picasso, Edgar Degas and Piet Mondrian. The jet-setting baron would also collect a series of wives, the last of whom, Carmen 'Tita' Cervera, helped convince him to establish the Thyssen-Bornemisza Museum in Madrid, where Henri's collection is now displayed. Today, the Thyssen-Bornemisza museum has a small but exquisite holding of works by Lucian Freud, one of which features the baron himself. Henri was already an admirer of Lucian when he secured a sitting with the artist in 1981. Though it was his first experience as an artist's 'model', he willingly subjected himself to nearly two years of sessions. Freud captures Henri in a pensive mood, and he includes a detail from an eighteenth-century canvas in the baron's collection—*Pierrot Content* by Jean-Antoine Watteau. *Portrait of a Man* is unusual for Freud in many ways. He rarely accepted commissions, and he almost never referred so directly to an earlier painting in his own work. The fact that he made these exceptions for the baron indicates a level of acceptance and friendship between the two men. Freud would later make a second portrait of the art-loving magnate entitled *Man in a Chair* (1983–85). He would also use *Pierrot Content* as inspiration for another, very different work of art— one that brought together members of Lucian's extended family.

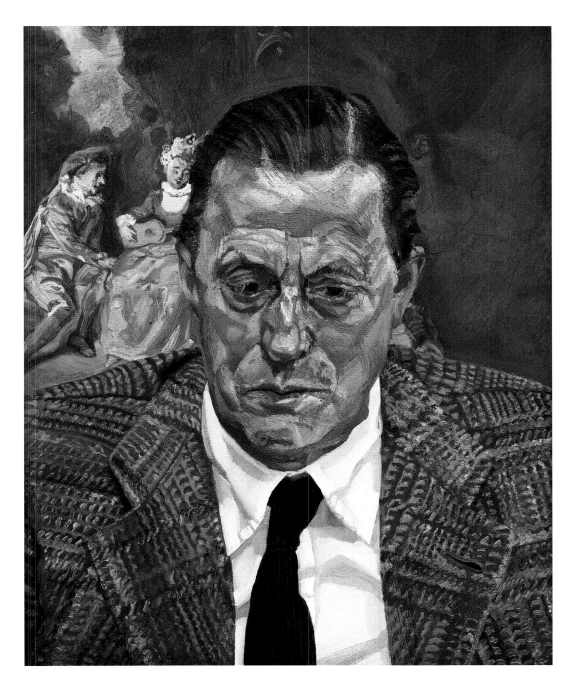

Still Life (Quinces), 1981/2

Oil on canvas
15.8 × 20.9 cm
Thyssen-Bornemisza Collection, Madrid

Throughout his life, Lucian Freud captured his love of nature on canvas. He believed
people, animals and plants all had a living energy and personality. Freud's ability
to depict that energy developed as his technique evolved. In early works, such as
Quince on a Blue Table (page 44), the fruit is highly detailed but somewhat inert,
like a painted wooden pome from a table setting. Later works, including *Bananas*
(page 54), remain meticulously rendered, but they begin to show an inner life. It
wasn't until Freud revamped his painting technique that the artist could fully express
the 'reality' of the natural world.

In *Still Life (Quinces)*, the fruits swell with pulpy vitality, their curving bodies compli-
menting the decorative porcelain tray. Freud achieves this through his bristly, twisted
brushstrokes, which define their shapes and help capture the play of sunlight on their
surfaces. The quinces remain highly detailed, with their blotchy patches of discolor-
ation and remnants of stems, but that detail is expressed in a much freer hand. The
tablecloth below is rendered even more sketchily, with streaks and patches of colour
suggesting a textile pattern.

The quince, a pear-like fruit, has been captured in art for centuries, from the photo-
graphically realistic still lifes of baroque Spanish master Juan Sánchez Cotán (1560–
1627) to the pulsating, expressionist renderings of Vincent van Gogh (1853–1890).
While not directly influenced by these works, Freud offered his own twentieth-
century interpretation of the evocative still life.

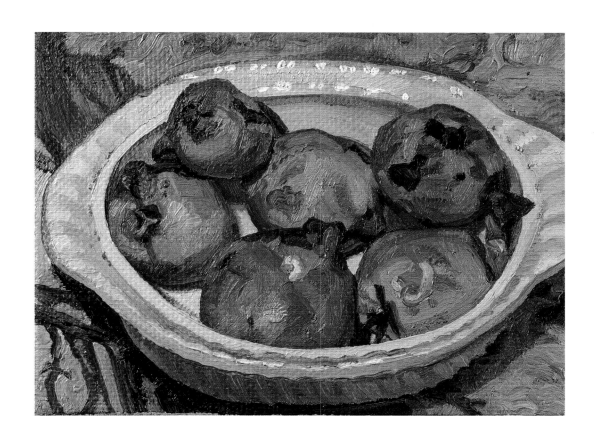

Large Interior, W11 (after Watteau), 1981–83

Oil on canvas
185.4 × 198.1 cm
Private collection

"That was a really hard picture to sit for, because it was so uncomfortable sitting upright holding this horrible mandolin and wearing this really uncomfortable dress that had gold thread in it, which was rather prickly. And also when we were all together, all the heat from the different bodies was really uncomfortable. But then after he'd ... sketched it and put us in place, we'd be probably two at a time and sometimes alone."
(Bella Freud on sitting for *Large Interior, W11 (after Watteau),* from the 2012 documentary film *Lucian Freud: Painted Life*)

In 1977, Lucian Freud moved into a capacious studio in the tiny neighbourhood of Holland Park, Kensington. He had been used to cramped studio quarters, and his art tended to reflect the intimate, confined world of working-class Paddington. But the new light-filled environment would provide an important source of inspiration for him, leading to new types of composition.

Large Interior, W11 was the first large-scale work painted in the new studio. Freud had recently begun the portrait of Baron H.H. Thyssen-Bornemisza, where he included a detail of a Watteau canvas (*Pierrot Content*) that resided in the baron's vast collection (page 70). Though Freud denied being "Watteau-mad" (see Further Reading on page 110, William Feaver, 2002, page 37), his work for Thyssen-Bornemisza led to a kind of re-staging of *Pierrot Content*. In place of the original work's rococo *commedia dell'arte* actors, Lucian used disparate members of his extended family to make the group portrait. The seated characters are, from right to left, Suzy Boyt, Freud's former lover; Kai Boyt, Suzy's son from an earlier marriage; Bella Freud, Lucian's daughter from a prior affair with Bernadine Coverley; and Celia Paul, a painter and Freud's current lover. The child on the ground, originally meant to be a Freud grandchild, is actually a boy unrelated to the painter. This image portrays the first sitting in which Lucian brought together different women from his romantic life. As Bella later confessed, the experience of making the work was not an ideal one. Critics, too, were less than kind to the piece at first, dismissing it as forced and self-indulgent. But with time, *Large Interior, W11* has become more admired. Artificiality and naturalism exist side by side, suggesting the duality of Freud's single-minded artistic life and his chaotic private world.

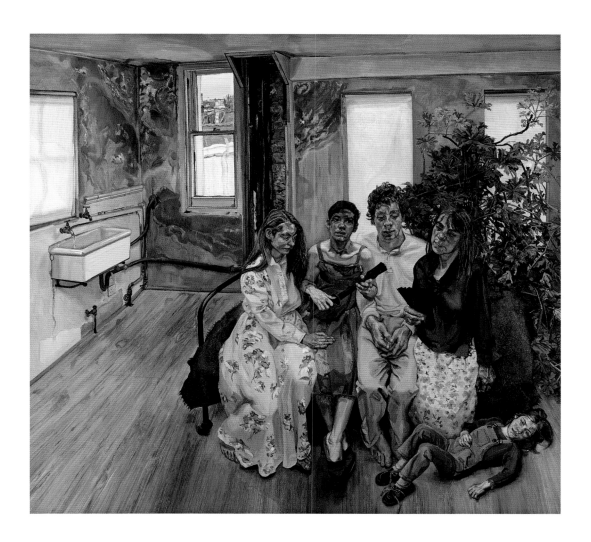

Two Irishmen in W11, 1984/85

Oil on canvas
172.7 × 142.2 cm
Private collection

"When I sat down with Alfie McLean at the end of the meal I asked what Lucian
owed him. I was thinking of some preposterous figure like 100,000. When he
spurted out 2.7 million I was blown away."
(Art dealer William Acquavella on Lucian Freud's gambling debts)

Lucian Freud was a gambling addict. Late in his life, he admitted to William
Feaver that "money was simply a fuel for gambling" and that he "always thought
of money as something I could always just get hold of somehow" (see Further
Reading on page 110, William Feaver, 2007). Despite Freud's critical acclaim, his
paintings were difficult to sell for large stretches of his career, and art dealers were
reluctant to handle his work. The resulting lack of income combined with gambling
debts meant that Freud was often relying on financial support from friends and
the few clients that sat for him. Some of these clients were aristocrats like Baron
Thyssen-Bornemisza. Others were like Alfie McLean.
McLean was a prominent bookie from Northern Ireland with whom Freud had
a long-term working relationship. In the early 1990s, when art dealer William
Acquavella took Freud on as a client, he met with McLean to ask about Lucian's
debts. Upon learning that they amounted to £2.7 million, a staggering sum at the
time, Acquavella worked out a plan to pay off the debts, which included McLean
purchasing some of Freud's art "at a better price" (see Further Reading
on page 110, further sources).
Alfie McLean had shown an interest in Freud's art long before his meeting with
Acquavella. He began posing for Freud in the seventies as 'big man', but his best-
known portrait is shown here. Freud captures Alfie as a domineering presence, his
powerful body and hands filling up the small chair. Behind him stands his teenaged
son, looking somewhat rigid and uncomfortable in his dark suit. Behind them
we see a window view of the houses of Kensington spreading westward, as well
as two small, unfinished self-portraits of Freud resting against the wall. Was this
image meant to serve as debt payment for McLean? Freud would remain largely
secretive about this relationship all his life.

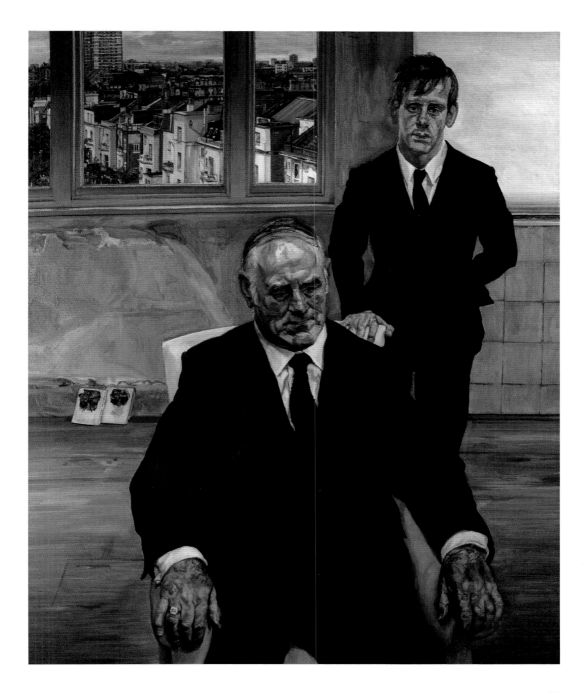

Reflection (Self-Portrait), 1985

Oil on canvas
55.9 × 53.3 cm
Private collection

"I do start more self-portraits and destroy more than any other pictures, because
in my case they seem to go wrong so very, very often. I haven't found a way of
doing them. Not that I've found a way of doing anything, but I feel that they should
become easier and they don't. There's also an important point—you can't see
yourself like you can other people. All you can see is a reflection, and I've tried to
paint the actual reflection that I see, which is why I actually call them 'reflections',
rather than for any poetic reason. [...] I try to avoid [...] any expression on my part
which seems to me to be viewing oneself in a pleasant or conciliatory light. And so
I notice from self-portraits very, very often that [...] people tend to [...] give them-
selves a kind of grandeur, which I'm not saying they haven't got, but which they
certainly don't give to other people. And I don't know if I succeed in this, but I'm
conscious of trying to avoid that very much. But then, of course, I think it would be
equally foolish to make yourself look meaner than you were, if this were possible.
Because it would be dramatising (oneself) in another way... in a more trivial way."
(Lucian Freud, from a 1988 BBC interview with Frank Auerbach)

Freud was never entirely comfortable painting his own portrait. His glowering face
in *Reflection with Children (Self-Portrait)* seems to be invested with the "mean"
countenance he tried to avoid. The painting shown here, possibly the most iconic
of all his self-portrayals, may err slightly on the side of "grandeur". The face and
shoulders are particularly sculptural, somewhat like the Rodin figures Lucian would
use to decorate his studio. Wrinkles and folds appear hardened and stony, compli-
menting the steely expression in the eyes. The more sensitive, vulnerable aspects
of Freud's nature seem to be hidden away under thick layers of grey, crème and
brown brushwork.

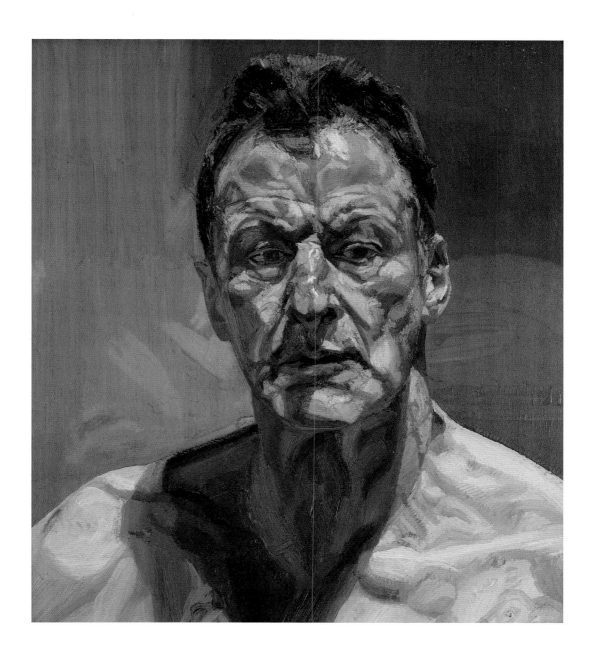

Two Japanese Wrestlers by a Sink, 1983–87

Oil on canvas
50.8 × 78.7 cm
Art Institute of Chicago, Chicago

"I am only interested in art that is in some way concerned with truth.
I could not care less whether it is abstract or what form it takes."
(Lucian Freud, from a conversation with Martin Gayford, 2003)

As Freud entered his sixties, he became increasingly interested in portraying
details of the world around him. In his early still lifes, such as *Quince on a Blue
Table* (page 44), the young artist combined personal objects in a fanciful
manner. But Lucian's later art was focused on capturing reality as he found
it—the things that are "just there" (see Further Reading on page 110, further
sources). This work captures an intimate 'portrait' of the sink in his Holland Park
studio, which can also be seen in *Large Interior, W11 (After Watteau)* (page 96).
With his deft, expressive touch, Freud gently forms the sink's smooth body and
rounded edges. Glistening trickles of water flow out of the brass spigots, falling
gently on the swirling brownish stains that lead down to the drain. Cracked
subway tile, rusting pipes and gaps in the wall give the feeling of comfortable
decay. Even the torn picture of Sumo wrestlers seems a natural feature within
this interior landscape. Freud's rendering of the cut-off bodies has the same
fluid expression as the rest of the painting's details.
This delicate tableau is an exquisite example of Freud's mature art. It com-
bines a modernist's eye for urban detail with the expressive realism of Gustave
Courbet (1819–1877), one of Freud's most admired artists. At its best, Lucian's
work is almost unique in the twentieth century for its ability to bridge the art of
different eras.

Annabel Sleeping, 1987/88

Oil on canvas
38.7 × 55.8 cm
The Devonshire Collections and the Chatsworth Settlement Trustees, Derbyshire

"I paint only the people who are close to me. And who closer than my children?
If I thought it odd to paint them, I would never have done so..."
(Lucian Freud from an interview with John Richardson)

Annie and Annabel Freud, Lucian's two daughters with his first wife Kitty, were the
only children he had in wedlock. Freud's life after Kitty was marked by a series of
affairs, occasionally more than one at the same time, which led to at least twelve
other offspring. Lucian was often secretive about these relationships, even among
his own family members. In an interview with editor Geordie Greig, Annie admit-
ted that until the mid-seventies, "I simply didn't know about Ali, Rose, Susie, Ib,
Bella, or Esther at all—none of them. I had no idea they existed. Or who their
mothers were. Not the slightest idea. At the time, I hadn't understood that you
can be, indeed that you have the right to be, angry with your parents so I felt
that I couldn't be angry, either." Annie would have a falling out with her father, in
part, because of this revelation. But she remained proud of the portrait sessions
she had with him, even the "shocking" (see Further Reading on page 110, Geordie
Greig, 2013, page 78) experience of modelling nude at age fourteen. *Naked Child
Laughing,* from 1963, shows the unclothed Annie in an overtly self-conscious pose.
It marked the beginning of Freud's exploration with naked body portraiture. As
Annie later relayed, "You would think it would have a bad effect on your feelings,
your sexual feelings or your body feelings, but it didn't. There wasn't any question
in my mind of a lack of trust of Dad."
Freud's other children also posed for him multiple times, often using the experi-
ence as an opportunity to get attention from their absentee parent. The portrait
here shows Annie's sister Annabel in a more modest, gentle posture. Her resting
body is turned away from the viewer, with only her dirty feet exposed. In the
background we see a pile of paint rags, an image Freud had begun incorporating
in his work. The messiness of the rags seems to compliment the informality of
Freud's vulnerable sitter.

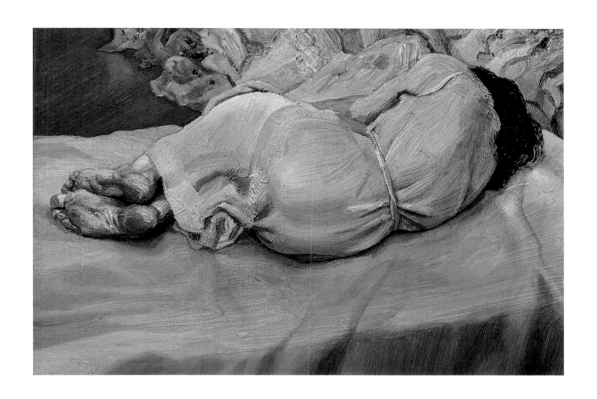

Standing by the Rags, 1988/9

Oil on canvas
168.2 × 138.5 cm
Tate Gallery, London

The rags that we see in *Annabel Sleeping* (page 82) have now become a main character in this more ambitious work. Freud normally used his rags for a utilitarian purpose, to wipe off excess paint from his brushes. But the crumpled texture of the cloth, especially when soiled with paint, seemed to captivate Lucian's eye. Here, the rags have been piled together to form a kind of mountain or cloud, on which the nude model rests her body. The pose of the model, with her head resting on her outstretched arm, may seem natural at first. But scholars suggest that Freud may have wanted the picture to remind viewers of artworks from the past.

One possible inspiration for this image is *Diana and Callisto* (1556–59), a master-work by the Venetian painter Titian. Freud particularly admired the work, and he would make long trips from London to Edinburgh in order to see it at the Scottish National Gallery. Titian's image depicts a dramatic moment in the story of Callisto, a mythological nymph. She has been raped by Zeus, and her pregnancy is being revealed to Diana, the goddess of the hunt—a humiliation that will soon lead to her expulsion from Diana's court. Titian shows Callisto's pregnant body in remark-able detail, with her swelling stomach and stretched-out navel exposed and her extended arm pinned against the body of another nymph. Freud's image, though far less violent in tone, creates a similar female body, with its natural swellings and prominently outstretched arm. Moreover, despite his woman's solid features and the gritty discoloration in her skin, Lucian achieves a feeling of weightlessness that is also characteristic in Titian's work. Once again, the hints of Europe's Old Master tradition appear in Freud's obsessively realistic twentieth-century art.

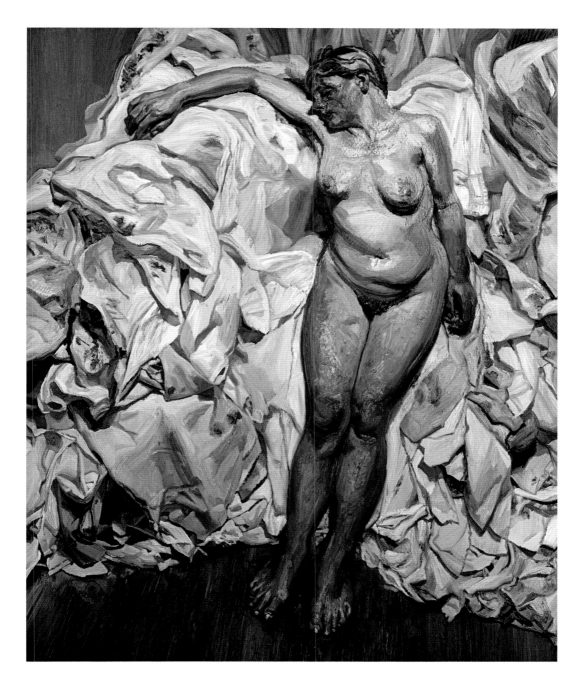

Naked Man, *Back View (Leigh Bowery)*, 1991/92

Oil on canvas
182.8 × 137.1 cm
The Metropolitan Museum of Art, New York

"There are parts of myself that I hadn't really thought about before but that I now really like, and other parts I'd felt uncomfortable about that I quite like as well ..." (Leigh Bowery on sitting for Lucian Freud, *The Independent*, 1991)

The 1990s marked another important turning point in Lucian Freud's career. He acquired a new dealer, William Acquavella, who would pay off his gambling debts and aggressively market his work. He would also become a celebrity among a new generation of cultural leaders and influencers.
Leigh Bowery (1961–95) was born in the suburbs of Melbourne, Australia. After spending a year studying fashion, he moved to London to begin a remarkable career as a club promoter and became an icon of the British underground. Bowery's club, the Taboo, was famous for breaking cultural and sexual mores— a place where people of different sexual persuasions could meet, get high, and enjoy Leigh's wildly eccentric costumes and performance art. Lucian Freud was introduced to Bowery in 1990 by Cerith Wyn Evans and his partner Angus Cook, artists who had recently sat for Freud in *Two Men in the Studio* (1987–89). Lucian was immediately taken with Bowery's great size, 190.5 cm tall and weighing around 108 kilos; as well as the elegance with which he moved his large frame. Bowery, in turn, was impressed with Freud's broad knowledge of art, and the two were soon working together in Lucian's studio.
Leigh became one of Lucian's most successful models, a man who seemed to enjoy experimenting with unusual poses for Freud to capture. (page 31) The painting shown here is the first product of their working relationship, a supreme example of Freud's talent for using the body to depict character. Bowery's face is almost completely hidden, but his powerful back and legs express great liveliness. The athletic posture and striking perspective remind the viewer of nineteenth-century art, such as Edgar Degas's impressionistic views of dancers or bathers. Bowery and Freud's relationship would aid the careers of both men. Leigh gained prestige in the fine art community, and Lucian soon became more relevant in the pop culture world of the nineties.

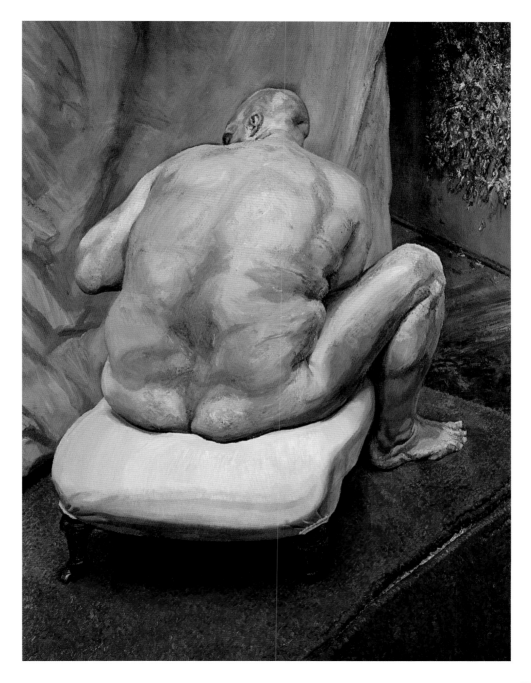

Painter Working, Reflection, 1992/93

Oil on canvas
101.6 × 81.9 cm
Private collection

"The naked body has done some quite good modelling. But you see the thing about this self-portrait is that I couldn't scrap it because I'd be doing away with myself. [...] I remember when I used to go down to Norwich one day a week (to teach) the one thing the students had in common was a sort of innate timidity of a very agreeable kind, but the antithesis really to the absolute cheek of making art. So I thought the best thing I can make them do to reveal themselves, is naked portraits. And now the very least I can do is paint myself."
(Lucian Freud from an interview with William Feaver, 1992)

Freud was still a remarkably youthful and spry artist at the age of seventy. His working method had long involved endless hours of standing while he applied paint to canvas, a regimen that also included bathing several times a day. One particular snapshot of Freud from only a few years before shows him standing on his head next to his daughter Bella. But despite his continued good health, Lucian began to explore on canvas the nature of his own decline and mortality.

For a long time, Freud had been perfecting his nude body portraits, images that often got to the essence of his sitters better than his portraits of faces. In *Painter Working, Reflection,* Freud at last turned his eye on his own body. The slender frame is still muscular and lithe, giving a sense of Lucian's tough, hard-scrabble character. But the roughly applied brushwork on the legs, chest and face suggest a decay of skin and bone, highlighted by the oversized, floppy boots. The slightly stooped upper body holds the brush somewhat wearily. Freud was losing the ability to fully extend and stretch his painting arm. And unlike his 1985 self-portrait (page 78), here Freud shows his face drawn and in contemplation. By adopting the same rigorous powers of observation that he used in all of his nude portraits, Freud here presents himself with unprecedented honesty.

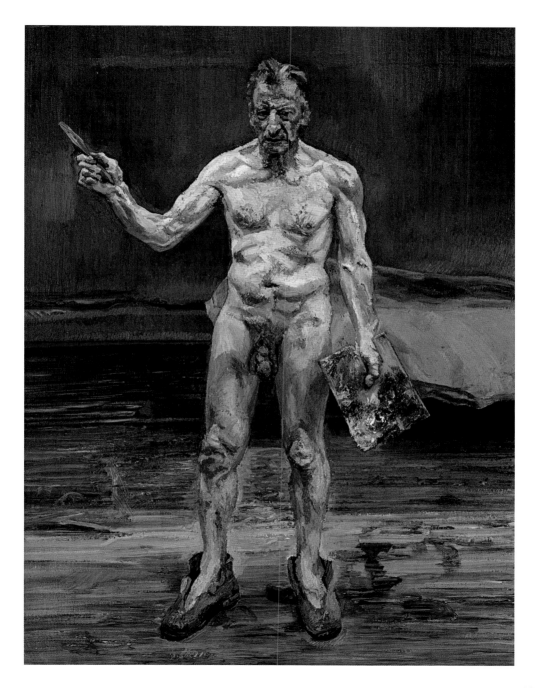

And the Bridegroom, 1993

Oil on canvas
231.7 × 196.2 cm
Private collection

"When I went to Lucian's studio, at the top studio flat up five flights of stairs in Holland Park, London, I always looked forward to seeing Lucian and having a good chat, usually about my previous day or nights' activities. ... I would amuse Lucian greatly—he had a wicked sense of humour, and I like to think I do as well. I was different than the other female models he painted and more similar to the gay models. We felt very comfortable in each other's company, and we would read the ten newspapers that Lucian got delivered daily.

Just to explain about the sitting or modelling times of Lucian, he had two or three paintings on the go at the same time. And there would be day paintings and night paintings with different models. A day painting would start at 7:30 in the morning, which is when Lucian expected his models to arrive, and after a cup of green tea and maybe a croissant, the sitting sessions would begin. The modelling would last for 35 to 40 minutes before a break of 10 to 15 minutes, and this would continue until 1:00 to 2:00 pm. Once the model would leave, Lucian would have a nap for a few hours.

The night paintings would start between 6:30 to 8:30pm depending on whether it was dark enough to continue and the light was right, as in winter it got dark early, but it was more variable in the summer. Lucian would always cook us dinner of partridge, lamb chops or oysters or lobster with a green salad and a raspberry vinaigrette, followed by custard and raspberry jelly tart I can't remember the name of. Lucian thought that a well-fed model would be more docile and settled and would sit for longer sessions at a time. These night paintings would go on until 1:00 to 2:00am, and Lucian would give us money for cabs home. A typical painting by Lucian could take 6 to 9 months for him to complete."
(Nicola Bowery on working with Lucian Freud)

Nicola Bateman worked with Leigh Bowery for many years as his assistant. For one of the duo's performances, Bowery simulated childbirth in a graphic, blood-stained manner—an act where he was the 'mother' and she the 'newborn'. The stick-thin Bateman and massive Bowery made for a somewhat outlandish pair. Freud's painting of them, however, has a rather tender naturalism that is far removed from their over-the-top stagecraft. In 1994, the openly gay Bowery would marry Bateman in what she would later call a "personal art performance" (see Further Reading on page 110, further sources). Less than a year later, Leigh Bowery would succumb to an AIDS-related illness.

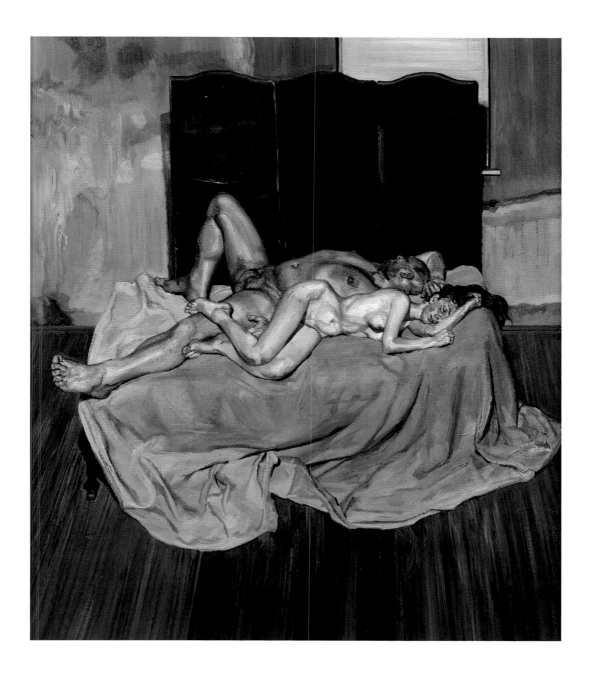

Benefits Supervisor Sleeping, 1995

Oil on canvas
151.3 × 219 cm
Private collection

"She's in her own way very feminine and, as she says, lucky she's got a sensible gene. Initially, being aware of all kinds of spectacular things to do with her size, like amazing craters and things one's never seen before, my eye was naturally drawn to the sores and chafes made by weight and heat."
(Lucian Freud on Sue Tilley, from an interview with William Feaver, 1998)

Like Nicola Bateman, 'Big Sue' Tilley became part of Leigh Bowery's Club, Taboo. Tilley worked as a club cashier at night, while her days were devoted to a London job centre, where she served as a benefits supervisor. In 1991, Bowery introduced Tilley to Lucian Freud, who began painting her the following year. As Freud admitted to William Feaver, "I have perhaps a predilection towards people of unusual or strange proportions, which I don't want to over-indulge." His best-known portrait of her, *Benefits Supervisor Sleeping*, shows the obese Tilley reclining in a couch with floral-patterned upholstery. Lucian's image is unsparingly honest in the way it portrays her bloated features, which Freud called "flesh without muscle" that "has developed a different kind of texture through being such a weight-bearing thing". Freud even captures the tense expression of a face that is only pretending to sleep. Lucian's 'Tilley' portraits continue to elicit controversy among his critics and biographers. Some see *Benefits Supervisor Sleeping* as a major achievement in late twentieth-century portraiture. Freud's image does have a sculptural power, which is reminiscent of the fleshy nudes in baroque art or the swelling bodies of prehistoric fertility carvings. Others see the works as exploitative and misogynist. Tilley herself was more sanguine about Freud, saying that he never hated women and that his paintings were made to "test and challenge and see how well he can paint". *Benefits Supervisor Sleeping* would sell in 2008 for more than £17 million, a record price for a painting by a living artist.

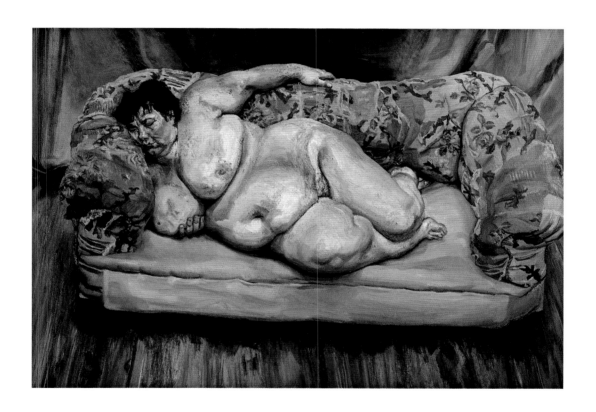

Garden, Notting Hill Gate, 1997

Oil on canvas
175.2 × 144.7 cm
Private collection

"I wanted to take on the garden because in the past I've either put the chunk indoors or done it from a distance. I was very conscious of where I was leading the eye. Where I wanted the eye to go but not to rest; that is, the eye shouldn't settle anywhere. [...] I realised that I could sustain the drama that I wanted in the picture by—as I nearly always do—giving all the information I can."
(Lucian Freud on painting his garden, from an interview with William Feaver)

Freud referred to this painting as his "race against autumn". The view depicts a great clump of garden plants, mostly buddleia and bamboo, from outside his house in Notting Hill, about a quarter of a mile away from his studio in Holland Park. It's a kind of portrait in extreme close-up, and Freud captures an astonishing range of detail. Drooping flower panicles—with only a few that still have their full summer colour—are bunched among twisting branches and leaves. Tinges of autumn yellow are seen amidst the late summer green. This image of life slowly going into hibernation resembles Lucian's aging human bodies, with their potmarks, skin discolorations and worn expressions.
The picture also captures Freud's restless eye—a restlessness he wanted his viewers to experience as well. Because the painter offers no focal point for the eye, the audience cannot easily take in the image at one glance. One's eye must travel around the canvas, examining different corners and details, in order to process all of the 'information' Freud provides. A close inspection will identify hints of butterfly wings. "I've got butterflies in there", Freud admitted, "surviving well beyond their natural span. The garden's sheltered and buddleia is a butterfly-attracter, but I did notice how amazingly late (in the season) they were, especially the white ones."
As time went on, Freud would paint more works at his Notting Hill home, eventually making the house his chief studio.

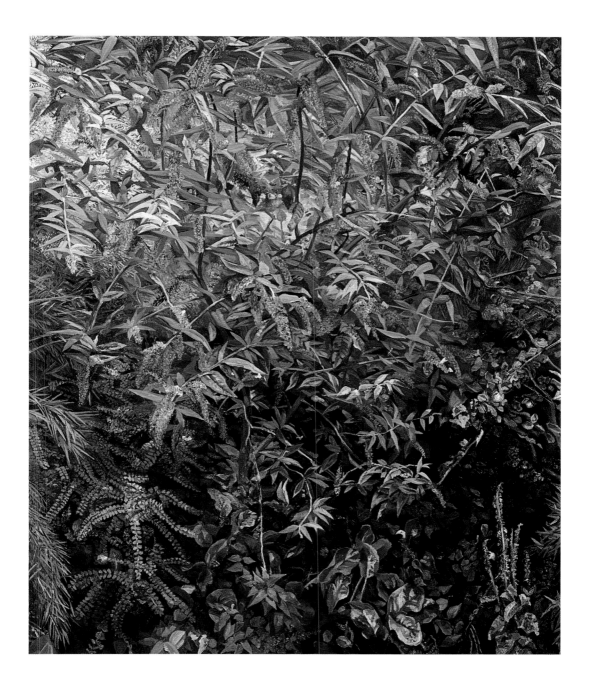

Large Interior, *Notting Hill*, 1998

Oil on canvas
215.2 × 168.9 cm
Dallas Museum of Art, Dallas

"In the picture I'm doing now, the biggest I've ever worked on, bigger than the Watteau (page 74), Jerry is naked, suckling the baby and Francis Wyndham is on the sofa reading Flaubert's letters. Jerry's not going to be prominent because it's so light by the window where she is. [...] The picture is sort of midday-ish with shutters up in one window, a view through the other, the street and cars and maybe someone walking, and I thought: make the paint thick there. I've painted with a lot of white, which will change to beigeish, whiteish, yellowish. The room looked terribly closed and I've opened it up; it suddenly seems a big, airy room. I quite like it being flooded with light of a very different kind from the light of *Garden, Notting Hill Gate*." (page 94)
(Lucian Freud on Francis Wyndham, Jerry Hall and the making of *Large Interior, Notting Hill,* from a 1998 interview with William Feaver)

Large Interior, Notting Hill is among Freud's most bizarre compositions. A dour older man reads quietly on a sofa, while a naked younger man behind him suckles a newborn child. The scene, with its warm, light-filled interior has at once an air of quiet contentment and a disorienting, surrealist edge. What is the relationship between the two men, and why has the younger man taken on the role of a Madonna? Freud's painting can be explained, in part, by its complicated history.
The older gentleman here is Francis Wyndham, an author and long-time editor of the *Sunday Times* magazine. Wyndham helped promote the work of numerous twentieth-century British writers, including Jean Rhys and Edward St. Aubyn, and he was a decades-long friend of Lucian Freud. The younger man is David Dawson, Freud's chief studio assis-tant. Dawson, however, was not originally meant to be an actor in this painted drama. By the late nineties, Freud's career had taken off financially, partly because of his work with Leigh Bowery and partly through the representation of high-powered New York dealer William Acquavella. Lucian's new fame was attracting celebrity clients, including Jerry Hall, the wife of Mick Jagger. Hall had posed nude for Freud when she was pregnant with her son, Gabriel, and she was then engaged to be the nursing figure in *Large Interior, Notting Hill*. Hall, however, proved to be a difficult sitter, failing to show up for painting sessions. Freud was unusually impatient with such behaviour, and he never let Hall back in his studio. Instead, he simply gave the nursing character a 'sex change', permanently erasing Hall's image from the work. Both Jerry Hall and Mick Jagger were incensed by Freud's actions, but Lucian was happy with the finished product, arguing that David helped make the 'drama' of the work more effective. As for the image's puzzling sexual undercurrents, Lucian never offered any direct explanation.

HM Queen Elizabeth II, 2000/01

Oil on canvas
23.5 × 15.2 cm
The Royal Collection, London

"It makes her look like one of the royal corgis who has suffered a stroke."
(Robin Simon, editor of the *British Art Journal*, on Lucian Freud's portrait of
Queen Elizabeth II)

As an artist steeped in history and tradition, and whose works have strong links to
the past, Lucian Freud was an ideal candidate to portray Queen Elizabeth II during
London's millennium celebrations. Freud's artistic heroes of the past, including
Titian, Diego Velazquez and Francisco de Goya, had all produced memorable
images of royalty. But Lucian's own contribution to this history would receive mixed
reviews.
According to biographer Geordie Greig and others, Freud acquired this presti-
gious commission from his long-time friend Robert Fellowes, the Queen's Private
Secretary and the brother-in-law of Diana, Princess of Wales. In a sense, the por-
trait represents Freud's life-long effort to court the admiration of Britain's elite. The
process of making the portrait, however, had limitations. For one thing, Freud was
unable to use his own studio for the sittings, instead travelling to the conservation
studio of St. James's Palace. "Of course, we had only a limited number of sittings",
Freud told biographer Sebastian Smee. "At one point I remember saying to her,
'You probably think I'm going incredibly slowly, but in fact I'm going at ninety miles
an hour, and if I go any faster the car might overturn.'" Freud decided to limit the
scale of the work and paint a close-up of Her Majesty's head, rather than a more
traditional royal bust with head and shoulders. With her pinched lips, the Queen's
expression looks somewhat strained. It's a less-than-regal countenance that led
some critics to dismiss Freud's portrait as dyspeptic and lacking insight into Her
Majesty's true nature. Others would praise the work as "honest", "clear-sighted"
and "thought-provoking" (see Further Reading on page 110, further sources).
Despite the critical disagreement, *HM Queen Elizabeth II* has become a popular
work at the Royal Collection.

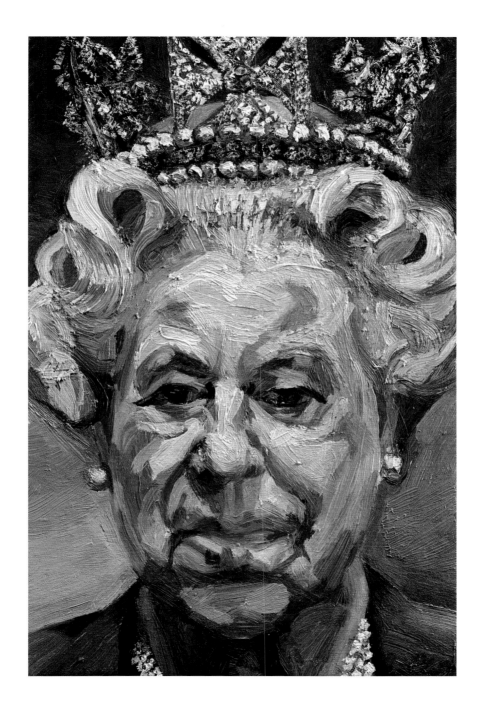

Naked Portrait (Kate Moss), 2002

Oil on canvas
152.7 × 122.2 cm
Private collection

"He told me about when he was in the navy, when he was 19 or something, and he used to do all of the tattoos for the sailors. And I went, 'Oh, my God, that's amazing.' And he went, 'I can do you one. What would you like?' I was like, 'Really?' He said, 'Would you like creatures of the animal kingdom?' I said, 'I like birds.' And he said, 'I've done birds. I've got it in my book.' ... So we decided to do a flock of birds. I mean, it's an original Lucian Freud. I wonder how much a collector would pay for that? A few million? I'd skin-graft it. I think we should talk to [the art dealer William] Acquavella.'"
(Kate Moss on her sitting with Lucian Freud, from an interview with James Fox for *Vanity Fair*)

Lucian Freud's daughter Bella, a prominent fashion designer, obtained one of her father's most famous commissions in 2002. English supermodel Kate Moss had expressed an interest in meeting Lucian, and Bella set up an engagement for her at Lucian's studio. Though it was advertised as "He just wants to go for dinner with you", the night ended with Freud beginning a large-scale portrait of Moss. For the next several months, sitting sessions lasted seven hours a day, three to four times a week. Moss was pregnant at the time, as Jerry Hall had been for her first portrait with Freud several years earlier; but unlike Hall, Moss was an ideal model, showing up promptly for every sitting. Freud and Moss developed a cordial working relationship, with Freud famously offering to tattoo Moss's buttocks—in memory of his earlier 'career' as a tattoo artist onboard the SS Baltrover during World War II. The finished painting features Moss reclining on a bed, her arm resting in a manner similar to that of the model in *Standing by the Rags* (page 84). *Naked Portrait* would sell for nearly £4 million at Christie's in London, and Kate would later get her Freud body tattoos appraised for more than £1 million.
Freud and Moss remained on good terms for the rest of the artist's life. In a touching photo from 2010, Moss embraced a sick-looking Lucian in his bed. The artist would die the following year.

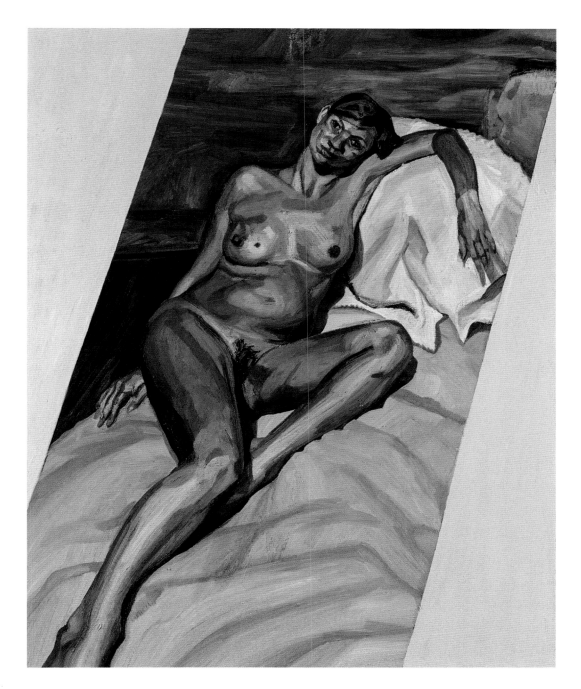

David Hockney, 2002

Oil on canvas
40.6 × 31 cm
Private collection

"He begins with a charcoal drawing, not that much, but enough to fix some essen-
tial things, the edge, approximately. And then he seems to begin with the nose. He,
I think, spent a long time here (around the nose), building this. [...] The eyes are not
put in for quite a while, and it would build up very slowly. He mixed every tone, and
it did occur to me at first, I thought, well, he could have been a bit quicker if he'd
premixed quite a few of them because they're quite similar, and then it wouldn't
take you as long to mix it. But [...] I then realised that I'm just thinking of myself [...]
he wants you to have as long as possible, so why not mix every colour slowly, mean-
ing he's got more time that way."
(David Hockney on sitting for Lucian Freud, from the 2012 documentary film *Lucian
Freud: Painted Life*)

At the same time Freud was painting the young model Kate Moss, he was also
portraying a forty-year-long acquaintance, David Hockney. Like Freud, Hockney was
one of Britain's indispensible modern artists. His images of California in the sixties,
with their acrylic blue skies, swimming pools, and blandly modernist houses, hinted
at a spiritual emptiness in suburban life and became icons of the pop art movement.
Hockney also shared Freud's work ethic, producing an extensive and wide-ranging
body of work from paintings to photocollages to iPad art.
The four months Hockney spent as Freud's model were a source of enjoyment for
him. The younger artist was keen to take in Freud's deliberate working method—the
way he mixed colours slowly in order to give him more time to observe his sitter's
face and attitude. And though Hockney had long been an eager adopter of new
technologies and art styles, he was taken with the "old-fashioned bohemia" (see
Further Reading on page 110, Geordie Greig, 2013, page 90) of Lucian's working
environment (page 33). The final portrait is a poignant example of a great artist
interpreting the character of another, just as effective as Freud's earlier image of
Francis Bacon (page 20). Lucian ably captures Hockney's no-nonsense inquisitive-
ness, revealing him as a penetrating, slightly gruff observer of life.

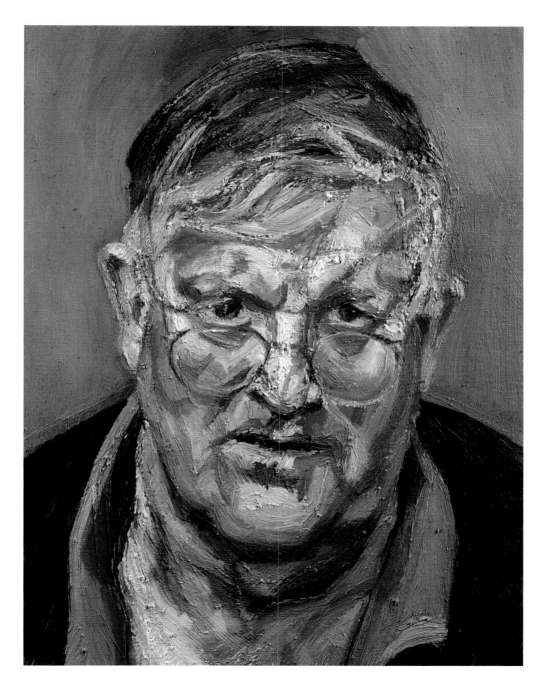

Self-Portrait, Reflection, 2002

Oil on canvas
66 × 50.8 cm
Private collection

"When I think of the work of Lucian Freud, I think of Lucian's attention to his subject.
If his concentrated interest were to falter, he would come off the tightrope; he has
no safety net of manner."
(Frank Auerbach on his friend and fellow painter Lucian Freud)

In 2002, William Feaver curated a major retrospective of Lucian Freud's art at the
Tate Gallery in London. An extensive display of paintings, drawings and other works
revealed Freud's evolution as an artist, beginning in the late thirties. The most
recent work at the exhibit was this revealing self-portrait. It illustrates a develop-
ment in his art that he had been exploring since the 1980s. Freud had long mastered
the use of bristly impasto brush strokes to give his portraits energy and depth.
But now those strokes were becoming more roughly applied, intentionally obscur-
ing facial features and giving the work an unfinished, almost abstract look. Here,
Freud's cheeks, forehead and prominent nose seem to dissolve into his skull, with
his eyes looking almost helplessly to the side. The hand and neck appear skeletal,
as though in the process of wasting away under the smoothly-rendered coat and
cravat. The same type of contrast can be seen in background, with the smooth
wooden wall merging into an almost abstract expressionist pattern—a detail that
might have been painted by Willem de Kooning or Jackson Pollock.
Freud uses these techniques to create an image of profound vulnerability. With his
bony hand clutching his cravat, Lucian seems to be protecting himself from his own
demons, and possibly his increasing fear of mortality.

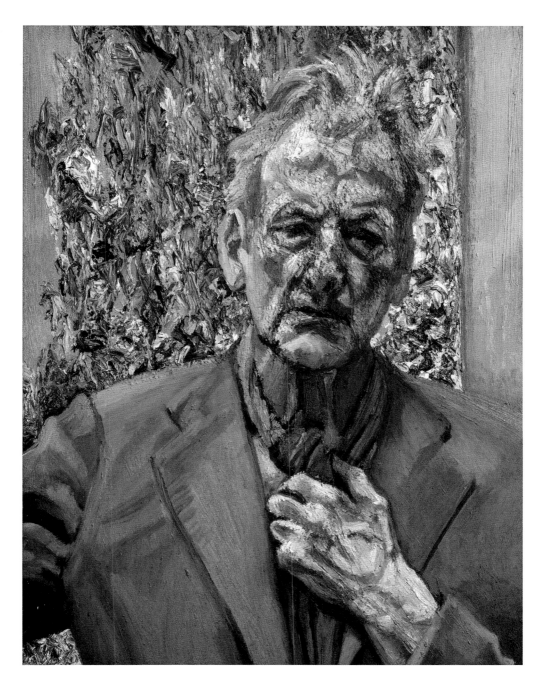

The Brigadier, 2003/04

Oil on canvas
223.5 × 138.4 cm
Private collection

Like a number of Freud's portrait subjects, Andrew Parker Bowles was born into the world of aristocracy. A career officer in the British army, Parker Bowles served as a chief military aide in Rhodesia in 1979, when it transitioned from a British colony to the independent state of Zimbabwe. He was also closely involved with the royal family, serving as a young page at Queen Elizabeth II's coronation in 1953, and dating the Queen's eldest daughter Anne for a short time in the 1970s. Later in life, however, Parker Bowles became best known as the first husband of Camilla Parker Bowles, the long-time love interest of Prince Charles. After years of living separately, Andrew and Camilla would divorce in 1995. Camilla eventually married the Prince of Wales in 2005, acquiring the title of Duchess of Cornwall.

Andrew Parker Bowles had been a friend and admirer of Lucian Freud for many years before this portrait was made. Both avid horsemen, the two were often seen riding together in Hyde Park, with Freud carelessly foregoing protective headgear. This friendship led, in 2003, to Parker Bowles sitting for Lucian at his house in Notting Hill. The brigadier's military career is on full display here, complete with boots, medals and embroidered cuffs and collar. This elaborate attire, however, is at odds with the scuffed-up chair, the stark walls and the subject's pronounced belly and sagging facial expression. To an extent, Freud's brigadier suggests an aging actor in an antique costume—an actor no longer on stage and somewhat uncomfortable in his current surroundings. Many critics have interpreted the work as an image of Britain's political decline and its loss of tradition and empire.

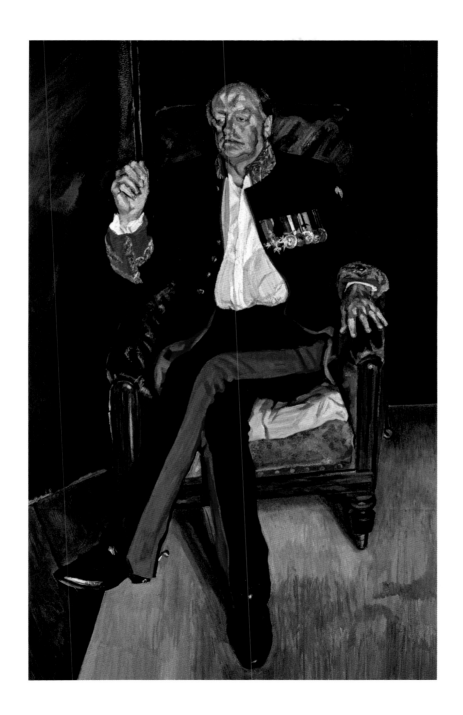

Portrait of the Hound, 2010/11

Oil on canvas
158 × 138 cm
Private collection

"He wouldn't have the canvas facing away from his subject, he would be side on mostly, so you could see him touch his brush to the canvas. His touch was very light and precise every time. He never did anything lazily. And he could keep it up for hours once he got going. I mean I can paint for two hours fully concentrating and then I am exhausted. It was the opposite with Lucian almost, the painting completely energised him. He would have to go out at the end of it because the adrenaline was still up. It was like being a stage actor or something, every night, I imagine."
(David Dawson on Lucian Freud, from an interview with Tim Adams for *The Observer*)

Painter David Dawson began working with Lucian Freud in 1991, after studying at the Royal College of Art. Though Dawson had been working alongside conceptual artist Tracey Emin and other edgy up-and-comers, he was immediately impressed with Lucian's seemingly traditional working methods. "I could see, at nearly 70, that Lucian was incredibly ambitious still for his work, And, oddly, I knew what I could do to help him." David spent the last twenty years of Lucian's life "clearing space for him to paint" and doing other odd jobs, such as photographing some of Freud's more important studio sessions. He also became Lucian's most useful portrait subject, often sitting with Eli, the painter's beloved whippet.
Freud's last major work, unfinished at his death, shows Dawson and Eli together on a bedsheet at the Notting Hill studio. As with many of Lucian's double portraits, human and non-human subjects are presented with the same naturalistic objectivity. Dawson's face, sketched with roughly applied brushstrokes, has the same inexpressive look as the dog. Freud reveals David's energy from within the body, revealing the presence of veins and pulsing blood flow beneath the skin.

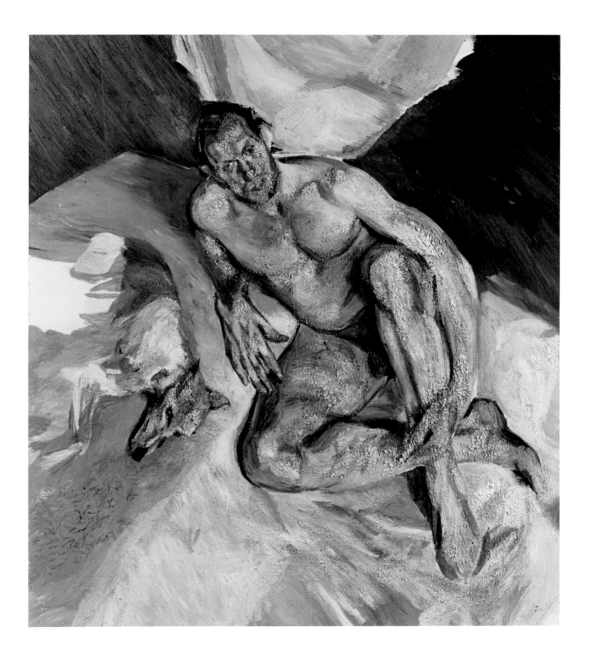

FURTHER READING

Debray, Cécile, *Lucian Freud: The Studio*, Munich 2010

Feaver, William, *Lucian Freud*, London 2002

Feaver, William, *Lucian Freud*, New York 2007

Feaver, William, *The Lives of Lucian Freud: The Restless Years, 1922–1968*, New York 2019

Figura, Starr, *Lucian Freud: The Painter's Etchings*, New York 2007

Gayford, Martin, *Man with a Blue Scarf: On Sitting for a Portrait by Lucian Freud*, London 2010

Gayford, Martin, *Modernists and Mavericks: Bacon, Freud, Hickney & the London Painters*, London 2018

Greig, Geordie, *Breakfast with Lucian: The Astounding Life and Outrageous Times of Britain's Great Modern Painter*, New York 2013

Haag, Sabine/ Sharp, Jasper (eds), *Lucian Freud*, Munich 2013

Hoban, Phoebe, *Lucian Freud: Eyes Wide Open*, Boston 2014

Howgate, Sarah, *Lucian Freud: Portraits*, New Haven 2012

Lampert, Catherine, *Lucian Freud: Recent Work*, New York 1993

Mellor, David, *Interpreting Lucian Freud*, London 2002

Smee, Sebastian, *Lucian Freud: 1996–2005*, New York 2005

Smee, Sebastian, *The Art of Rivalry: Four Friendships, Betrayals, and Breakthroughs in Modern Art*, New York 2016

PHOTO CREDITS

Material was kindly made available to us by those museums and collections named in the illustration credits, or are from the publisher's archives, with the following exceptions:

FURTHER SOURCES

Two Irishmen in W11, 1984/85
Upon learning that they amounted to £2.7 million, a staggering sum at the time, Acquavella worked out a plan to pay off the debts, which included McLean purchasing some of Freud's art "at a better price".
http://johnshaplin.blogspot.com/2014/03/lucian-freuds-bookie-by-geordie-greig.html, accessed on 17 September 2019

Two Japanese Wrestlers by a Sink, 1983–87
But Lucian's later art was focused on capturing reality as he found it—the things that are "just there".
https://www.google.com/amp/s/amp.theguardian.com/artanddesign/2012/feb/02/lucian-freud-artist, accessed on 17 September 2019

And the Bridegroom, 1993
The stick-thin Bateman and massive Bowery made for a somewhat outlandish pair. Freud's painting of them, however, has a rather tender naturalism that is far removed from their over-the-top stagecraft. In 1994, the openly gay Bowery would marry Bateman in what she would later call a "personal art performance".
From Leigh Bowery's obituary:
https://www.independent.co.uk/news/people/obituaries-leigh-bowery-1566637.html accessed on 17 September 2019

HM Queen Elizabeth II, 2000/01
Others would praise the work as "honest", "clear-sighted" and "thought-provoking". "honest" and "clear-sighted" from Richard Cork, *London Times*:
https://www.rct.uk/collection/themes/exhibitions/the-queen-portraits-of-a-monarch/windsor-castle-drawings-gallery/queen-elizabeth-ii-b-1926
"thought-provoking" from:
http://news.bbc.co.uk/2/hi/entertainment/1723071.stm
all accessed on 17 September 2019